CARAVAGGIO

Eminent Lives, brief biographies by distinguished authors on canonical figures, joins a long tradition in this lively form, from Plutarch's *Lives* to Vasari's *Lives of the Painters* to Dr. Johnson's *Lives of the Poets* to Lytton Strachey's *Eminent Victorians*. Pairing great subjects with writers known for their strong sensibilities and sharp, lively points of view, the Eminent Lives are ideal introductions designed to appeal to the general reader, the student, and the scholar. "To preserve a becoming brevity which excludes everything that is redundant and nothing that is significant," wrote Strachey: "That, surely, is the first duty of the biographer."

GENERAL EDITOR: JAMES ATLAS

ALSO BY FRANCINE PROSE

CARAVAGGIO

Painter of Miracles

Francine Prose

EMINENT LIVES

ATLAS & CO.

HARPER PERENNIAL

NEW YORK • LONDON • TORONTO • SYDNEY • NEW DELHI • AUCKLAND

HARPER ● PERENNIAL

Illustrations follow page 86.

A hardcover edition of this book was published in 2005 by HarperCollins Publishers.

FIRST HARPER PERENNIAL EDITION PUBLISHED 2010.

Designed by Elliott Beard

The Library of Congress has catalogued the hardcover edition as follows:
 Prose, Francine.
 Caravaggio: painter of miracles / Francine Prose.
 p. cm.—(Eminent lives)
 ISBN 978-0-06-057560-1
 1. Caravaggio, Michelangelo Merisi da, 1573–1610. 2. Painters—Italy—Biography. I. Caravaggio, Michelangelo Merisi da, 1573–1610. II. Title. III. Series.
 ND623.C26P76 2005
 759.5—dc22 2005040203

ISBN 978-0-06-176890-3 (pbk.)

11 12 13 14 RRD 10 9 8 7 6 5 4 3 2

For Howie, again

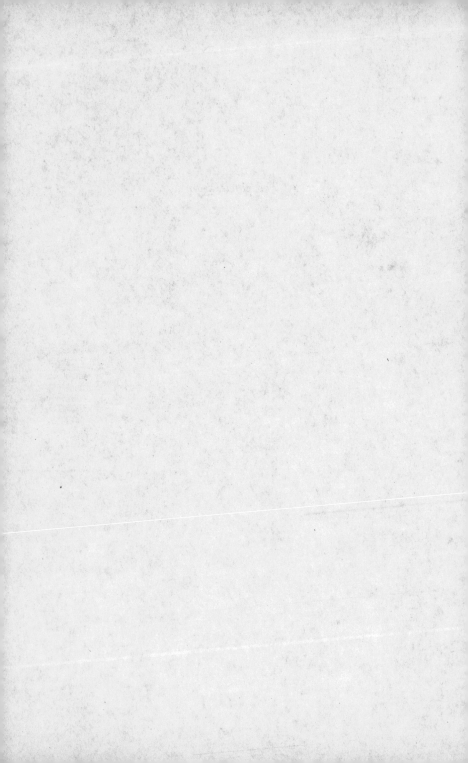

H E WAS THIRTY-NINE when he died, in the summer of 1610. He had been in exile, on the run, for the last four years of his life. He slept fully clothed, with his dagger by his side. He believed that his enemies were closing in on him and that they intended to kill him.

He was wanted for murder in Rome, for stabbing a man in a duel that was said to have begun over a bet on a tennis game. It was not the first time that he had been in trouble with the law. He had been sued for libel, arrested for carrying a weapon without a license, prosecuted for tossing a plate of artichokes in a waiter's face, jailed repeatedly. He was accused of throwing stones at the police, insulting two women, harassing a former landlady, and wounding a prison guard. His contemporaries described him as mercurial, hot-tempered, violent.

Michelangelo Merisi, known as Caravaggio, was among the most celebrated, sought after, and highly paid painters in Rome.

But not even his influential patrons could arrange for the murder charge to be dismissed. After the crime, he fled to the hills outside the city, and then to a village near Palestrina, where he could have lived safely under the protection of the Colonna family, who were among his patrons, and beyond the range of papal jurisdiction. But the bucolic small town must have seemed dull compared to the chaotic street life of the Campo Marzio, to the taverns, the whorehouses, the gang fights, and—most important for Caravaggio—the fierce, energizing competition with his fellow artists, most of whom he despised.

In Rome, he had seized every opportunity, however impolitic or inappropriate, to criticize his contemporaries and to advance his own ideas about the true purpose of art—ideas he held with the force of a fanatical conviction and that fueled his erratic behavior, his vertiginous descent from wealth into vagrancy, and his ultimate self-destruction. In retrospect, his contempt and impatience seem more understandable: the frustration of a genius surrounded by a great deal of very bad, very popular, very lucrative and respected art.

During the years he spent in flight, he painted almost constantly. And despite or because of the impossible pressures and makeshift working conditions, his art became even more ambitious, darker and more deeply shadowed. Months after the murder, he turned up in Naples, where he completed two major altarpieces and a number of smaller canvases. But once again he grew restless. Perhaps he was being followed, or perhaps he just thought so. In any case, he felt that he had no choice but to leave the city.

Sometime before, he had challenged his former employer and subsequent rival, Giuseppe Cesari, the Cavaliere d'Arpino, to a duel. The *cavaliere* had replied that, as much as he would have liked to fight, his status as a Knight of Malta prevented him from participating in pointless street brawls with men who, not being knights, were beneath him. Now, as Caravaggio decided where to go after Naples, the old insult may possibly have factored in to his decision to sail to Malta. He would become a Knight of Malta, he would join the Order of Saint John of Jerusalem, a confraternity of soldiers who took monastic vows of poverty and chastity and who pledged to defend the Christian faith. Also he may have heard that the Maltese were seeking a painter to decorate the Cathedral of Saint John in Valletta.

His experience in Malta established a pattern that would be repeated throughout his exile from Rome. Because his fame had preceded him, and thanks to his contacts in the Maltese capital, he was welcomed by the local nobility and given prestigious commissions. He painted furiously, brilliantly. Driven by his belief in the importance of working from nature, he employed live models whom he posed in theatrical tableaux re-creating scenes from the New Testament and from the lives and deaths of the early Christian martyrs. Always, he reimagined these dramas in novel ways that reached beyond the conventions of art to tap directly into the power and resonance of biblical narrative, and to engage the viewer with an immediacy that made these dramas of suffering and salvation seem comprehensible and convincing. Often ahead of his patrons, the

people responded to an art that reminded them that these miracles had transpired neither in primary colors, nor in brilliantly hued paintings of sanitized saints and celestial fireworks, but in dusty streets and dark rooms much like the streets and rooms in which they lived.

Inevitably, his work was widely discussed, passionately admired or hated, and his fees increased along with his reputation. As he traveled, awaiting the pardon that might enable him to return to the capital, he seemed to have found a way of surviving, of supporting himself and practising his art away from the reliably generous patrons and the distracting intrigues of Rome. And then, just as inevitably, something would go wrong.

So, in Valletta, he succeeded in having himself appointed a Knight of Malta—not an easy task, since the honor was mostly reserved for sons of the nobility. Doubtless his knighthood had something to do with the influence of his supporters in Rome, and with the magnificent portrait he did of the grand master of the Knights of Malta, Alof de Wignacourt. But again the artist's situation took a sudden and drastic turn for the worse. Caravaggio insulted a fellow knight, a superior, and was imprisoned in the notoriously escape-proof fortress, Valletta's Castel Sant'Angelo.

Caravaggio escaped. Pursued, he believed, not only by the pope's men but now also by a posse of vengeful Maltese knights, whose military code of honor had been grievously affronted, he fled to Sicily. In Syracuse, he was reunited with Mario Minniti, a close friend and fellow artist who had served as Caravaggio's model and with whom

he had lived in Rome. During his sojourn in Syracuse, Caravaggio painted *The Burial of Saint Lucy* for the church of Santa Lucia, where the virgin martyr had originally been entombed.

In the winter of 1608-9, he left Syracuse for Messina, where he promptly received a commission to paint *The Resurrection of Lazarus.* According to one early biographer, he destroyed the first version of the painting when he felt that it had been underappreciated by the doltish provincials who were now his principal patrons. Later he repainted it, presumably assisted by the same local laborers he asked to carry the corpse he used as the model for the dead Lazarus. After a fight with a local schoolmaster who alleged that Caravaggio stared too fixedly at the young male students, he left Messina for Palermo, where he painted a Nativity, which was later destroyed in an earthquake.

From Palermo he returned to Naples. There, he was wounded—killed, people said—in a fight at a tavern. His face was slashed and so disfigured that he was nearly unrecognizable; it was assumed that the attack had been arranged by his old enemies from Malta. While he recovered, he began a series of smaller paintings for the influential Romans who were pleading his case. Ultimately, he received word that he had at last been granted an official pardon for the 1606 murder.

Bringing along several paintings, he set sail for Rome. But en route he suffered a chance misadventure—and then a disaster. In a Tuscan port, which was at that time under Spanish jurisdiction, his ship was detained. Perhaps mistaken for someone else, Caravaggio

was held for questioning. The tide turned, and the ship went on without him.

Two days later, he was released from prison. Ill, most likely with malaria, enraged, desperate, possibly delirious, he decided to chase the boat that had sailed off with all his possessions and paintings. When that failed, he resolved to walk along the scalding beach and catch up with the ship farther up the coast. He got as far as Port'Ercole, where he collapsed and died of fever in the small infirmary run by the brothers of San Sebastiano.

Within days, reports of his death had spread throughout Rome. It was rumored, and then confirmed, that he had died at Port'Ercole, and that before his death he had been pardoned by the pope. The bishop of Caserta was sent to track down the missing paintings, one of which, a Saint John the Baptist, was found in Naples and now hangs in the Galleria Borghese in Rome.

It seems entirely appropriate that his paintings survived that last voyage, those final days of bad luck, bad timing, and bad judgment. For history has proved that this last unfortunate turn of events was indeed a promise for the future, a portent of the fact that Caravaggio's work would outlive the drama and violence of his life.

And yet that promise would not be kept for several centuries, during which the question of his immortality was perpetually in the balance and the survival of his art was far from guaranteed. For more than three hundred years, his work was despised or simply ignored. One of his early biographers, Giovan Pietro Bellori, set an example for future critics by claiming that he "emulated art—astonishingly

enough—without art," that he "suppressed the majesty of art" and "devalued beautiful things." Caravaggio, wrote Bellori, "possessed neither invention, nor decorum, not design, nor any knowledge of the science of painting. The moment the model was taken away from his eyes his hand and his imagination remained empty."

According to Nicolas Poussin's friend and biographer, André Felibien, Poussin despised Caravaggio and said that he had come into the world to destroy painting. For Caravaggio's portrayals of whores, criminals, and laborers with rough hands and dirty feet threatened what Poussin considered to be the most essential principle of art—specifically, the notion that the artist should represent ideal beauty, perfect proportion, and classical decorum. Moreover, Caravaggio's belief in painting directly on the canvas ran counter to Poussin's insistence on the necessity of elaborate planning and preparatory drawing. In 1789, the historian Luigi Lanzi wrote that Caravaggio's figures "are remarkable only for their vulgarity," and during the Victorian era, John Ruskin grouped him "among the worshipers of the depraved."

It's shocking to realize how long that judgment prevailed and how very recently it was reversed—not until the 1950s, when a major exhibition in Milan reminded the world that one of its greatest artists had been overlooked. And yet it seems less startling when we realize that, while Caravaggio was very much a creature of his era, he was also an anomaly, one of those visitors from the future who touch down sporadically along the time line of art, a painter who simultaneously disregarded and redefined the conventions of his age,

who borrowed from antiquity and from the masters who preceeded him while stubbornly insisting that he had no interest in the past or in anything but nature, the street life of his neighborhood, and the harsh realities around him. Caravaggio was a preternaturally modern artist who was obliged to wait for the world to become as modern as he was.

In our own time, his work has become so popular that it's hard to be alone with his paintings for very long. In European and American museums, and in the Italian churches where his canvases and altarpieces can also be found, you can almost always locate the Caravaggios by following the crowds.

On an ordinary winter morning, several dozen people have gathered at the Contarelli Chapel in Rome's Church of San Luigi dei Francesi. On one wall of the chapel is Caravaggio's *The Calling of Saint Matthew*. Facing it is his depiction of Matthew's martyrdom, of the murder of the elderly saint on the steps of the altar, where he is being seized by the half-naked executioner about to run him through with a sword. Between these two paintings is Caravaggio's *The Inspiration of Saint Matthew*, an image in which the same saint whose violent death is so graphically portrayed in the painting beside it kneels at a desk, writing, and turns away from his manuscript to find an angel suspended in the air, hovering over his shoulder, dictating or reminding him of something that belongs in his Gospel.

An English tour guide is lecturing her large and rather restless group on the *The Calling of Saint Matthew*. She explains that the

work is based on a verse from the Gospel of Saint Mark: "And as he passed by, he saw Levi the son of Alphaeus sitting at the receipt of custom, and said unto him, Follow me. And he arose and followed him." She urges her charges to note the shaft of dusty golden light that enters from the right of the painting, the same side on which Jesus stands, accompanied by a disciple, presumably Saint Peter. She suggests they admire the way the light catches Christ's outstretched hand as Jesus points at Matthew, who, in turn, points at himself, quizzically and in obvious awe and wonder.

Seated at the table in the left half of the painting are three young men. Two of them are elegantly dressed pages in feathered hats; both regard Jesus with blank and slightly goofy looks of half attention. A third boy stares down at the coins on the table, gathering them toward him, while an old man in spectacles and a fur collar leans over Matthew's right shoulder.

The tour guide suggests that everyone take notice of how much Jesus's gesture recalls God's in Michelangelo's *Creation of Adam* in the Sistine Chapel, and she informs them that this chapel was Caravaggio's first major public and religious commission. But even the most dutiful tourists have long since stopped listening. There is nothing she is telling them that they absolutely need to hear, and the power of the paintings is drowning out her voice.

Because the truth is that it is possible to understand this painting without knowing much about art history, or Caravaggio, or even, perhaps, about the New Testament. None of that is necessary to comprehend what Caravaggio is showing us: the precise moment at

which a man's life changes forever—and becomes something else completely. By the time this moment has ended, Levi will have become Matthew, and the world he steps into will bear no resemblance to the world he is leaving now, the world of the counting-house. As Matthew points at himself—does Jesus really mean him?—some part of him intuits that the course on which he is embarking will lead inevitably to the bloody and terrible martyrdom that, if he were standing where we are standing, he could see across the intimate space of the Contarelli Chapel.

Unless you get close enough to a Caravaggio to see his brush-strokes—an impossibility in the chapel, which is plunged into blackness as soon as someone stops feeding coins into the light machine, though you could see a lot more if you allowed your eyes to accustom themselves to the dimness—you tend to forget that what you are looking at is, after all, only canvas and paint. Which is a pity, because one of the most astonishing things about his work is the fact that he was able to make paint and canvas communicate *exactly* what he wanted to convey—the paradoxical ordinariness of a miracle, the fact that these miracles happened not only to patriarchs or saints in haloes and robes, not only to levitating figures in ethereal firmaments surrounded by feathery clouds, but to human beings whose faces resemble faces we know, and who share our inescapably human doubts and pain and fear. By making us inescapably aware that we are looking at flesh-and-blood men and women, painted from nature, Caravaggio emphasizes the humanity of Christ and his disciples, of the Virgin and the Magdalene.

Unlike so many of his contemporaries and later artists, such as Poussin, Caravaggio never tries to make us imagine that the figures we are seeing are biblical or mythological figures. Instead he reminds us that we are looking at models, theatrically lit and posed for long periods of time, often in considerable discomfort, so that the artist could portray a single moment. What Poussin may have meant when he referred to Caravaggio's mission to destroy painting was, paradoxically, Caravaggio's determination to make it clear that he *was* painting.

Caravaggio speaks to us directly, without any need of translation from a distant century or a foreign culture. His voice is eloquent and strong, resonant with emotion. We feel we understand him, though we can never paraphrase what we intuit he is saying. His work is beautiful by any standard, except perhaps by those of John Ruskin and the other critics who dismissed his work as coarse and vulgar. Yet only lately, since we have learned to accept the idea of art without conventional beauty, art that is rough and strange and disturbing, can we tolerate art that is this *honest* about the nature of suffering and divinity, about the way in which a painting is created, about human nature, and the nature of art itself.

It's not hard to understand why the repressed and prudish Victorians would have been appalled by a painter with such an unflinching view of the way sex and death pull the strings, turning all of us into their marionettes. Or why a critic like Ruskin would have been horrified by an artist with so much to say about the pain that people, given half a chance, obediently or willfully inflict on one

another. Or about the grief involved in simply being alive, first in being young, ambitious, ready to conquer the world, and then in growing old, ill, weak, suffering and dying. Even, or perhaps especially, now, we are unaccustomed to seeing such fierce compassion untempered and unmediated by sentimentality.

Tracking Caravaggio through the course of his meteoric career, studying his paintings in chronological order, you can watch his models age along with him. He repeatedly inserted his own portrait—his dark, craggy, surly features, his increasingly lined forehead—into his work, so that centuries later we can trace every scar and groove etched by time as he appears to us in the face of a witness to the murder of a saint, or in the severed head of the dead Goliath that David holds at arm's length and as far as possible from his pretty young body.

The world needed to mature, to evolve past eighteenth-century decorum and Victorian prudery in order to accept the sexuality of Caravaggio's paintings, a sexuality that is at once bravely unapologetic and furiously private. It's worth noting that the spike in Caravaggio's popularity took place during an era in which our sensitivities were being simultaneously sharpened and dulled by artists like Robert Mapplethorpe, whose passion for formal beauty and stillness, and whose own brief dramatic career, made him as emblematic of his time as Caravaggio was of his. In order to love Caravaggio, we ourselves had to learn to accept the premise that the angelic and the diabolic, that sex and violence and God, could easily if not tranquilly coexist in the same dramatic scene, the same canvas, the same painter.

These contradictions partly explain why Caravaggio so nearly fulfills every popular notion—and cliché—about the personality of the artist. The genius, or so we have learned, is a soul in the process of being drawn and quartered, pulled in countless different directions, a psyche struggling to balance the impulse to seduce against the compulsion to offend, weighing the desire for acceptance against the terror of confinement, laboring to calibrate the optimal chemistry of compassion and loathing, despair and transcendence. Several of Caravaggio's earliest biographers grudgingly admired his art while condemning his bad behavior and distancing themselves from his famously difficult personality. And until very recently, critics were still making a strenuous effort to distinguish the living devil from the angelic, immortal artist.

Only now can we admit that we require both at once. The life of Caravaggio is the closest thing we have to the myth of the sinner-saint, the street tough, the martyr, the killer, the genius—the myth that, in these jaded and secular times, we are almost ashamed to admit that we still long for, and need. The arc of his life seems biblical as it compresses the Bible's core—the fall of man, the redemption of man, the life eternal and everlasting—into one individual's span on earth, one painter's truncated existence. Each time we see his paintings, we are reminded of why we still care so profoundly about this artist who continues to speak to us in his urgent, intimate language, audible centuries after the voices of his more civilized, presentable colleagues have fallen silent.

*　　*　　*

One could say that Caravaggio has gotten what he wanted. His controlling desire, it appears, was not so much for wealth or personal fame as for a much purer sort of recognition. He wanted the greatness of his work to be acclaimed and understood. He wanted his ideas about art to be accepted as gospel, though he bridled and exploded whenever he felt that a disciple was following too closely in his footsteps. And finally he wanted his paintings to be acknowledged as vastly superior to anything else being done in his own time. Had he wanted us to know more about him, he might have left more evidence, documents and detritus, clues to his existence. But there is almost nothing. Police reports, legal depositions, court transcripts, cross-examinations, public notices, promissory notes, and contracts for commissions give us what few facts we have about Caravaggio's biography.

Only very rarely do we hear him speak, and, except for the testimony that he gave at his trial for libel in 1603, it is always through the ventriloquism of others. He had, it would seem, two themes. One of his topics was insult, and the other was art. The insults are noted and preserved in the criminal record, the long list of provocations and responses that repeatedly got him into trouble. But we also hear him discoursing on the subject that meant most to him, on the correctness of his aesthetic theories and of the path he chose. His voice comes through in the famous anecdote about his boastful insistence that the first Gypsy woman who passed by on the street was a more appropriate subject for art than was any classical sculpture, and through the court records of a libel trial in which he used his appearance on the witness stand as an opportunity to hold forth on the

qualities that constitute a good artist. There was nothing else that he appears to have cared about. And when, during his last years in Rome, he felt that his primacy was beginning to slip, that the light of respect and acclaim was beginning to shine on artists like Guido Reni, whose work he detested, disappointment and anger drove him to the edge of a sort of madness.

Ultimately, he has left us his paintings as the incontrovertible proof of what he believed, of what he practiced, of how right he was. That, too, is what he would have wished: that the eloquence of his work should offer the decisive testimony and tell us all we need to know. But this means that for nearly everything else we must depend on his early biographers—Giovanni Bellori, Giulio Mancini, Karel van Mander, Joachim von Sandrart, and Francesco Susinno. The earliest, Giovanni Baglione, was Caravaggio's contemporary, a painter who competed with and deeply resented Caravaggio, whose work Caravaggio detested, and who was also the plaintiff in the libel suit that named Caravaggio as a defendant. How are we to interpret the account of lifelong rival who sums up Caravaggio's legacy in this almost comically ambivalent coda: "If [he] hadn't died so soon he would have made a great contribution to art because of the skill with which he painted things from nature, even though he showed poor judgment about representing the good and omitting the bad. Even so, he became well known, and was paid more for painting a head than other painters received for whole bodies, which proves that reputation has more to do with what people hear about an artist than with what they see. His portrait is in the Academy."

All we know, or think we know, about Caravaggio has been

subject to revision and reinterpretation. Informed guesses made by early biographers harden into facts in the work of later writers, while events recorded by those same biographers and long accepted as truth are later—after years of research have failed to substantiate them—dismissed as anecdotes with little basis in reality. There are protacted, undocumented periods in his short life, and considerable uncertainty about such seemingly straightforward matters as his place and date of birth.

He was not, as was once believed, poor and uneducated, a self-taught brute who came out of nowhere to overthrow and revolutionize the well-mannered, conventional, moribund art of his day. In fact his family was relatively prosperous. They owned land near Milan, in the village of Caravaggio, where they belonged to the new middle class.

His father, Fermo Merisi, worked principally in Milan as a chief mason, builder, architect, and majordomo for Francesco Sforza, the Marchese di Caravaggio, whose wife, Costanza, was a member of the illustrious Colonna family. In January 1571, Fermo married his second wife, Lucia Aratori, who was also from the town of Caravaggio. Francesco Sforza attended the wedding, which suggests that Fermo Merisi was a respected member of the *marchese*'s household. That autumn, Fermo and Lucia's son Michelangelo was born, most probably in Milan.

His birth occurred at an extraordinary moment in the history of our culture. Shakespeare's life span, from 1564 to 1616, was remarkably close to Caravaggio's. And indeed an intensely Shakespearean

spirit—theatrical, compassionate, alternately and simultaneously comic and tragic—suffuses Caravaggio's art, though it must be noted that Shakespeare possessed a considerably more panoramic and forgiving view of human nature. In the year of Caravaggio's birth, Galileo was a boy of seven, in Pisa; Claudio Monteverdi was a child of four, in Cremona. Rubens would be born six years later, in Westphalia.

It was also a period during which whole generations of artists were periodically wiped out by the virulent plagues that were notably indifferent to status, talent, and reputation. Titian was killed by the pestilence that swept through northern Italy in 1576. During that same epidemic, Carlo Borromeo, the bishop of Milan, was beloved for the courage he showed in remaining in his city to help the suffering victims, even as other church and civic officials fled to the countryside. A seventeenth-century painting shows Saint Carlo Borromeo ministering to the ill, possibly in the Lazaretto di San Gregorio, the plague hospital that, by the early 1800s, could accommodate 16,000 victims.

Throughout Europe, Italy had long been known for its efficient and relatively—that is, by the abysmal standards of the day—effective methods of plague control, a system that imposed draconian measures on both the sick and the healthy. The dead were buried in mass graves, their clothing and possessions burned. The families of victims were walled up in their houses, and the legal penalties for defying quarantine laws often involved torture and death.

Understandably, Fermo Merisi decided to move his family from Milan to the comparative and, as it would turn out, deceptive safety

of his hometown. As so frequently happened, the disease proved hard to outrun, especially when it was being imported to the rural areas by refugees from the city. In one night, Caravaggio's father and grandfather succumbed to the plague; his uncle had died not long before. Michelangelo's mother was left alone (fortunately, with the support of her parents) to raise her four children and a stepdaughter.

Caravaggio is believed to have received at least the rudiments of a formal education, which at that time would have included the Greek and Latin classics. Decades later, his work would display the lifelong legacy of an effective religious training. His younger brother would go on to study at a prestigious Jesuit college in Rome, and it seems likely that the two brothers started out in school together. Even for a painter, however, Caravaggio had notably little interest in writing—unlike, say, Leonardo da Vinci, who composed learned treatises on subjects ranging from art to medicine and warfare. Nor was he moved to record, or comment on, the events of his life, as was Jacopo Pontormo, whose diary offers intimate updates on the fluctuating state of his appetite and his digestion. No letters from Caravaggio survive; neither, like Michelangelo Buonarroti, did he leave us written work that included poems and grocery lists. Not a single drawing or preparatory sketch by Caravaggio has ever been discovered.

As far as we know, Caravaggio wrote nothing about himself, certainly nothing about his childhood, and his adult life seems to have included no one who had known him as a boy. Indeed, when his younger brother, Giovan Battista, who had become a priest, asked to

see him in Rome, Caravaggio—by then a successful artist—claimed that he did not know him, that they were not brothers at all, that he had no relatives. The rejected Giovan Battista replied "with tenderness" that he had not come for his own sake but for that of his older brother, and for that of his family, if God was someday to grant Michelangelo a wife and children of his own. Tenderness, indeed! Perhaps there was a double edge to this selfless fraternal valediction, since by then it must have been clear to all involved that Caravaggio was unlikely to settle down and become a family man.

After the horrors of the 1576 plague, Caravaggio vanishes from recorded history until April 6, 1584, when a contract was drawn up to certify the official beginning of his apprenticeship in the Milan studio of Simone Peterzano, a former pupil of Titian and a competent but unexceptional painter of religious scenes. Little is known about why young Michelangelo chose a career in art, nor is there much evidence about the earliest manifestations of his talent, though one anecdote relates how, as a small boy helping his father in his duties as a builder for the Colonna family, Michelangelo prepared glue for, and became fascinated with, a group of painters hired to fresco the palace walls. One biographer claims that he attracted attention when, as a child, he scrawled in charcoal on a wall. What does seem undeniable is that the young Caravaggio had plenty of opportunity to study great painting and sculpture in the churches of Milan and even in his hometown, where frescoes by Bernardino Campi decorated a local church.

According to the terms of Michelangelo Merisi's contract with

Simone Peterzano, the thirteen-year-old apprentice agreed to live with the painter for four years, to work constantly and diligently, to respect his master's property, and to pay a fee of twenty gold *scudi*. In return Peterzano agreed to instruct his pupil in the necessary skills (presumably drawing, perspective, anatomy, fresco painting, and the transformation of pigment into paint) so that, at the end of his apprenticeship, he would be capable of making his living as an artist.

In 1588, the apprenticeship ended. The next year, Caravaggio's mother died. For a brief time after that, Michelangelo shuttled back and forth between Milan and Caravaggio, settling, sorting out, and rapidly spending what remained of his inheritance.

The next thing we know is that he left Milan for Rome in the autumn of 1592. Perhaps he sensibly realized that for a painter the opportunities for employment and advancement would be greater in the epicenter of ecclesiastical and aristocratic power. Or, like any ambitious young man, he resolved to follow his luck to the source of influence and wealth. He may have been tired of Milan with its painful associations, its gloomy history of misery, plague, and famine. Several of his biographers suggested that he murdered a man in Milan and had to leave town in a hurry. Possibly he had already begun the first of the successive cycles of violence, escape, flight, and exile that would recur, with increasingly disastrous consequences, throughout his life.

Mancini states that Caravaggio's hot temper frequently made him act in outrageous ways. Bellori reports that because of his turbulent and quarrelsome nature, and because of certain disputes, he left Milan and traveled to Venice, while a note on another manu-

script mentions that he fled the city after killing a companion. Still another inscription on yet another manuscript, this one in an almost indecipherable scrawl, refers to an incident involving a whore, a slashing, daggers, a police spy, and a jail term.

Something happened. He left Milan. He decided to go to Rome.

In the Salone Sistine, at the Vatican, there is a fresco depicting the Piazza Santa Maria del Popolo around the time when Caravaggio first arrived in Rome. The scene suggests the main square of a prosperous rural town on a day when the farmers' market happens not to be in session. The animals—donkeys pulling overloaded carts, horses, a flock of sheep—nearly outnumber the humans. In the lower right-hand corner, a man is spreading an impressive quantity of laundry out to dry on grassy bank. In the background is the Church of Santa Maria del Popolo, where, less than a decade after Caravaggio arrived—from the north, through the Porta del Popolo, then the principal gateway into the city—he would paint the masterpieces that now adorn its Cerasi Chapel. Bisecting the fresco is the obelisk from the Circus Maximus, which Pope Sixtus V ordered erected in the square, and which remains the fixed point around which the street life of the modern piazza swirls. You can use these landmarks to orient yourself as you try to stretch your imagination far enough to encompass the fact that the semibucolic public space portrayed in the fresco is the same one that—swarming with pedestrians dodging buzzing *motorini*, surrounded by stylish cafés at which there is still an occasional movie-star sighting—occupies its site today.

Paradoxically, the tranquillity of the scene in the Vatican fresco

was an indication of fresh energy, of recovery and resurgence. In 1527, Rome had been entirely destroyed, looted and razed by the army of Charles V, the Holy Roman Emperor. Churches and palaces were burned to ashes, citizens tortured into surrendering the last of their wealth. It was said that not a single window in Rome was left unshattered. Some 45,000 Romans—including many artists and cultural figures—fled their ravaged city, which promptly lapsed into ruin and decay.

Only in the last decades of the sixteenth century had the city begun to rebuild, largely under the direction of the visionary Pope Sixtus V, who launched an ambitious progam of urban revitalization, building monuments, reorganizing neighborhoods, replacing the tangles of alleyways with broad avenues connecting the major basilicas. But late-sixteenth-century Rome was still a long way from the urban paradise that Sixtus envisioned.

A wave of migration from rural areas—inspired less by the capital's attractions than by the hope of escaping the grim cycle of bad weather, crop failure, and famine—severely overtaxed the resources of a city in which there was virtually no industry except for the few wool and silk mills Sixtus helped to establish. As a result of the zeal with which new churches and palaces were being planned and constructed, the building trades provided the principal opportunities for employment. But still there were not nearly enough jobs for the poor who begged in the streets, their desperation increased by the plagues and famines of the 1590s, their numbers swelled by the hordes of indigent pilgrims who flocked to the city's shrines.

Confraternities of priests and lay brothers were founded to aid beggars and pilgrims, and to bury the anonymous paupers who simply dropped dead on the street. Exemplary figures like Saint Filippo Neri sought to make the teachings of the church accessible to the common man, an ideal that would later guide Caravaggio as he conceived his great religious paintings. Meanwhile the rich—aristocrats, bankers, financiers, church officials—were actively setting new standards of ostentation and display, cultivating a taste for luxury and ornamentation that expressed itself in their jewels, clothes, carriages, daughters' dowries, and the decoration of their palaces. Under the reign of Clement VIII, who had been chosen pope earlier in the same year in which Caravaggio arrived in the Eternal City, the Roman cardinals became avid art collectors and patrons.

This was the world Caravaggio entered when he moved from Milan to Rome—poor himself, but possessing a skill that might prove useful and amusing to the rich. With its stark divisions between the indigent and the privileged, the culture provided him with the high contrasts that he observed meticulously and incorporated in his art. For among the qualities that made, and continue to make, his work so original and enduring was an acute power of observation: the ability to see how age and gender, social status and occupation, expressed themselves not only in gesture and dress but in tendon and knuckle, elbow and wrist, in the depth of a furrow and the droop of an eyelid.

Every social class makes at least a cameo appearance in his work, but in his final and greatest Roman paintings, the poor have claimed

center stage. He lived with them and understood them. By the time he painted his *Madonna of Loreto* for the Church of Sant'Agostino—a scene in which a stately, graceful Madonna appears with her son in a doorway of an ordinary house that evokes so many doorways in Rome—the calloused, bare, filthy feet of the pilgrims who kneel before her strike us as being as familiar to Caravaggio as the back of his own hand.

In his choice of models he worked his way up from the demi-monde to the world of the honest laborer and the pious, devoted poor. Near the start of his career he was drawn to portray cardsharps and thieves, criminals at work, pretty-boy musicians, and his Roman neighbors dressed up in the costumes and attitudes of saints. If his art depended on observing nature, on paying close attention to the visible world, there must have been plenty of opportunity to witness the full range of illicit activity in the taverns and streets around him, and to find visually arresting faces and characters that required only a costume change for their transformation from street whores into repentant Magdalenes and virginal Madonnas resting on the flight into Egypt.

According to a census taken in 1600, the population of Rome was approximately 110,000. It was a city of men, a fact that will become important when we consider Caravaggio's social and sexual life. Males outnumbered females, of whom there were 49,596. Of that number 604 were prostitutes by profession. A decade before, it had been reported—apocryphally, it is now believed—that the courtesan population of Rome totaled 13,000. Throughout the countryside,

banditry had reached epidemic proportions, and in the city, crime was so rampant that Pope Sixtus V decreed that robbers should be beheaded and their lopped-off heads arranged on the bridge across the Tiber near the prison in the Castel Sant'Angelo. Public executions provided a popular form of free mass entertainment.

Gangs of toughs—the *bravi*—roamed the neighborhoods, looking for trouble, dueling (a practice that had been outlawed by papal decree), battling over obscure points of personal honor, frequenting brothels, and vying for the affection of the most desirable prostitute of the moment. The Italians' reputation for violence and banditry spread beyond their own cities and dangerous country roads. Just as Anglophones today can't seem to get enough of the misbehavior of the Corleone and Soprano Mafia families, British playwrights of sixteenth and seventeenth centuries—Caravaggio's contemporaries and near-contemporaries—mined Italian street life and exaggerated the sad histories of Italy's spectacularly dysfunctional and incestuous noble families for the plots of their gory dramas. Many of the revenge tragedies written by Tourneur, Webster, and Ford—plays that ended with the stage littered with corpses, the victims of poisonings, stabbings, swordfights, and garrotings—were set in Italy or on occasion in Spain, anyplace where a tempestuous Southern temperament and a Latin lack of impulse control could be guaranteed to satisfy the audience's taste for dashing swordplay and for ingeniously plotted (poison might be concealed in the pages of a Bible or in a bouquet of flowers) and cold-blooded murder. Indeed, the violent incident that initiates the dramatic action in *Romeo and Juliet*—the

eruption of a street fight that ends in the death of Juliet's cousin and Romeo's banishment from Verona—was very much like the lethal brawl that forced Caravaggio to leave Rome.

Belligerent, contemptuous, competitive, Michelangelo Merisi would soon be drawn into the whirlwind of insults, attacks, retaliations, and vendettas that passed for nightlife in the Campo Marzio, the raffish neighborhood in which many artists, including Caravaggio, lived. And yet he somehow managed to stay out of trouble with the law until close to the end of the century. In the meantime, he had a career to begin and attend to. For one of the most remarkable things about Caravaggio was that, even when his private life was at its most chaotic and disordered, nothing (or almost nothing) prevented him from painting. While a number of his colleagues were famous for the extent to which they delayed and procrastinated, carousing in the taverns when their commissions were months overdue, Caravaggio generally succeeded in finishing his assignments on time.

New in Rome, living "without lodgings and without provisions," he resisted the siren song of the sword and the street. He did what his contract with Simone Peterzano had promised he would be qualified for: He found work as a painter.

Despite the poverty, disease, and crime that were the daily lot of so many Roman citizens, it was not an inauspicious moment for an ambitious and gifted young artist seeking to make his mark in the capital. From a purely economic standpoint, the scores of new palaces

and churches under construction meant that someone would have to be hired to paint and decorate them. Moreover, it was widely agreed—though of course not by the established painters—that art had grown tired, that the static formality and the conventions of high mannerism could use some revitalizing infusion of originality and passion. Important collectors complained publicly about the paucity of genuine talent.

Pope Clement VIII's ascension brought some measure of stability to the city. Previously the brief reigns of three short-lived popes had done little to control the sudden resurgence of banditry and crime. Flanked by his two nephews, Pietro and Cinzio Aldobrandini, who would become his closest advisers, Clement VIII—known for his asceticism and for the copious tears he shed during religious services—indulged his interest in philosophy, science, and literature. Under the auspices of Cinzio Aldobrandini, the famous poet Torquato Tasso was invited to Rome, where he remained to work on his epic, *Gerusalemme Liberata*.

Caravaggio's entry into the higher echelons of Roman social and cultural life was not nearly so seamless or smooth. Penniless, dependent on the hospitality of strangers, he moved frequently from cheap inns to spare rooms in the homes of acquaintances of his father's former employer and of his uncle, a church official. His departures rarely featured fond farewells and warm invitations to return. For a while, he stayed in the Palazzo Colonna, with Monsignor Pandolfo Pucci, a steward in the household of the sister of the former pope, Sixtus V. But Pucci forced the proud young artist to do

work that he found degrading, and to make knockoff copies of devotional paintings. In addition, he nearly starved him on a frugal diet, so that later Caravaggio referred to Pucci as *Monsignor Insalata*.

After his unsatisfactory sojourn with *Monsignor Insalata*, Caravaggio briefly and barely supported himself by making pictures to sell on the street. The biographical accounts of whom he stayed with and how he survived are as jumbled and contradictory as his life must have been during this unsettled period. He was said to have spent time in the atelier of a Sicilian who produced cheap art, and it was there that he may have met Mario Minniti, a young Sicilian artist with whom he lived, possibly for years, and who served as a model for several of the luscious, dark-eyed boys in Caravaggio's early paintings. Ultimately, Minniti returned to Sicily, married, and had children—and was later called upon to be his old friend's protector, host, guide, and business agent in 1608, when Caravaggio turned up in Syracuse, in flight from Rome, Naples, and Malta.

In a marginal note, written by Bellori in the manuscript of Baglione's biography of Caravaggio—the same inscription that notes that Caravaggio was forced to leave Milan after having committed a murder—Bellori writes that the young painter found work painting three heads a day in the studio of Lorenzo Siciliano, and from there moved on to the employ of Antiveduto Grammatica, a more esteemed and established painter of heads. But the first job that has been convincingly documented took Caravaggio, for eight months or so, into the busy, prosperous studio of Giuseppe Cesari, later known as the Cavaliere d'Arpino.

A favorite of at least two popes and several powerful cardinals, Cesari was nearly as prickly and difficult as Caravaggio, but far more tractable and eager to please—qualities reflected in the safe presentability of his art. After working on the Vatican frescoes, he was awarded a series of prestigious commissions that included frescoes in the Churches of Santa Prassede and San Luigi dei Francesi, and in the Basilica of San Giovanni in Laterano, where he demonstrated his ability to manipulate perspective and foreshortening in order to give the viewer a sense of rising into the firmament in the company of the apostles and saints.

If Caravaggio's paintings are brilliant, nearly photographic representations of miracles in progress, Cesari's frescoes more often evoke the illustrations in Sunday school textbooks. Indeed, Cesari is one of the many of Caravaggio's contemporaries whose work reminds us of what it is easy to forget or overlook—that is, how revolutionary Caravaggio was, how much he changed and rejected: the baby-blue heavens, the pillowy clouds, the airy ascensions accompanied by flocks of pigeonlike cherubs and choirs of attractive angels. For Caravaggio, the lives of the saints and martyrs and their dramas of suffering and redemption were played out among real men and women, on earth, in the here and now, and in almost total darkness.

In addition to his religious frescoes, Cesari turned out stylish canvases, quasi-erotic treatments of such mythological themes as Perseus rescuing a nude, provocatively posed Andromeda from the jaws of a predatory monster. These smaller works were sold, for respectable prices, to patrons and collectors. It's possible that Caravaggio helped

Cesari with his church commissions, but Bellori informs us that Caravaggio's duties were more limited, that Cesari deployed Michelangelo Merisi's talents solely in the decorative representation of flowers and fruit, an activity that was considered to be inferior to figure painting. As a consequence of this reluctant apprenticeship, Caravaggio became a skillful painter of still lifes, although he resented being "kept away from figure painting."

Ultimately, Caravaggio could not be prevented from using his masterful renderings of flowers and fruit as a decorative element in the kind of figure painting for which he was so temperamentally suited. Two of his earliest paintings—the so-called *Sick Bacchus* and *Young Boy with a Basket of Fruit*—were probably done when Caravaggio was still working in Cesari's studio. Both works graced Cesari's collection until, in 1607, they were seized by Pope Paul V and given to the acquisitive Cardinal Scipione Borghese. Perhaps the impecunious young Michelangelo sold them to his employer, or perhaps Cesari appropriated them when Caravaggio left his studio under the shadow cast by his lengthy and mysterious stay in the Hospital of Santa Maria della Consolazione.

This long, unexplained illness was described as resulting from a kick by a horse, though the so-called equine mishap may have been the era's equivalent of running into a door. Rumors of violent crime linked Caravaggio, Giuseppe Cesari, and Giuseppe Cesari's brother (and fellow painter) Bernardino Cesari, who was already a well-known felon. And there were hints of dark reasons why the brothers failed to visit their friend during his protracted recuperation.

It could hardly be mere coincidence that Caravaggio's enigmatic self portrait as the *Sick Bacchus* was painted at around the time of this serious illness. In the painting, a young man in a classical toga with an ivy wreath on his dark curls and a bunch of grapes in his hand regards us over his alluringly bare and muscular shoulder. Everything about his posture and his knowing, ironic ghost of a smile would suggest lasciviousness and sexual invitation, except for one little problem: Bacchus looks diseased, hollow-eyed, bilious. Green. What he offers is sex and death neatly combined in one simultaneously appealing and repellent package. His expression is unfathomable. Is he inviting the viewer to kiss him, or is he pleading to be rushed to a doctor? In the complicated art-historical debate about the painting's symbolism, iconography, and meaning, few critics have bothered to point out the obvious: how deeply strange the painting is. It's almost as if Caravaggio had discovered surrealism more than three centuries prematurely, and found himself unable to resist the impulse to produce something this outrageous and peculiar while employed in the studio of one of Rome's most conventional painters.

Sick Bacchus is the evil twin of *Boy with a Basket of Fruit*, which features another young man with bare shoulders, dark curls, and bunches of grapes. Here the straw basket is filled with the slightly overripe, imperfect fruit. Even at this early stage, Caravaggio was asserting his right to paint accurately, without idealization, a flawed and imperfect nature. It's hard to imagine two more dissimilar figures than Bacchus and the fruit bearer. For this boy is as rosy, as luscious and healthy, as the ripe peach in his basket.

Through the boy's pink, half-parted lips, we can glimpse the tip of his tongue. His head is tipped back, his eyes sleepy and half lidded, as if he has just had sex or is just about to. His smooth, lovely neck swans up from the deep well of his clavicle. Every cell of his being communicates enticement and seduction, and seems intended to make viewers long to remove that one last obstacle that separates us from him, to take the basket of fruit from his hands, set it down, and embrace him.

The intention of the boy, the painting, and painter is essentially the same: to so completely seduce us that we feel we can't live without this boy, or at least his representation. Ambitious, restless, probably bored in Cesari's employ, eager to strike out on his own but understandably uneasy about how he could support himself, Caravaggio was, at this point, one of those streetwise young men who cannily and shrewdly—and sometimes with unhappy consequences—understand that seduction is a likely route to survival. Nearly all his early paintings read like calculated attempts to charm and beguile the viewer, the collector, the patron, the buyer. His musicians, his singers, his chubby Greek gods fix us in their vampish sights and won't let us look away, while his cardsharps and fortune-tellers coyly pretend not to see us while they work their ruses and scams, knowing full well that we are watching.

But then the most remarkable thing is how drastically all of that changes. Beginning with the earliest of his great religious paintings—*The Calling of Saint Matthew* and *The Martyrdom of Saint Matthew*—the players in his dramas turn their backs on the viewer

and focus their full attention on the mystery they are enacting. In his later works, the come-hither glance has given way to the anguished grimace; the bare smooth shoulder has been replaced by the torturer's muscular buttocks and the filthy feet of the pilgrim. And the paradox is that even as these figures lose all interest in us, and in how we are reacting, we are caught up and drawn in even more strongly than we were when they were trying to invite us. In fact, everything is still calculated to work its magic on the viewer, to make us feel that a miracle is transpiring in front of our eyes, that it is happening to people like us, that we can touch and feel and smell it.

One of Caravaggio's last paintings portrays the full figure of a nearly naked boy, said to represent the youthful Saint John the Baptist. Beside him, a fat old ram, thickly horned, shows us his hindquarters. The painting is thought to be one of the works that Caravaggio made to present as a gift of propitiation or thanks to the patrons who were arranging the pardon that would let him return to Rome. It was presumably one of the paintings on the boat that sailed away without him and left him to die on the beach at Port'Ercole.

In the boy's dreamy, slightly melancholy prettiness, you sense that old urge to charm and beguile. But somehow it fails, and the final effect is anything but seductive. The boy looks wan, exhausted, used up. His dark eyes and the childish slope of his shoulders make us feel vaguely anxious and oppressed. He seems to have seen and suffered some of what his creator has endured. Caravaggio may still have been trying to charm and please, but his heart—worn out by travel and trouble—was no longer in it.

* * *

Eventually, Caravaggio recovered from his "kick from a horse" and was pronounced well enough to leave the Hospital of the Consolation. And whatever he experienced there seems to have strengthened his resolve to quit Cesari's art factory.

Now, Bellori tells us, "he began to paint according to his own genius . . . and nature alone became the object of his brush." This is when it was suggested to him that a figurative painter should seek inspiration in the idealized and pleasing proportions of classical sculpture, and when Caravaggio replied that he would rather find his models among the Gypsy women in the street. Throughout Caravaggio's work—in the poses and gestures of his sinners and saints, in the stance of a Madonna, the grimace of Medusa, the languor of Bacchus—you can see his familiarity with Greek and Roman art, and the extent to which that knowledge formed him. And yet you never feel that he is simply dressing up an idealized and imaginary Greek figure in a sixteenth-century costume, or that he is following the example of the ancient Greek painter whose image of Helen of Troy was said to be a composite combining five perfect body parts from five different women. Rather Caravaggio persuades us that he is finding the classical grace in the prostititutes he employed as a models, or borrowing the techniques that the Greeks used to render expression and animation in his efforts to depict the awe and terror of the neighbors he paid to pose as witnesses to a miracle or a martyrdom.

Obviously, Caravaggio did not invent the idea of direct observation from nature. Leonardo da Vinci's sketchbooks are full of draw-

ings of elderly or grotesque men and women that the artist made after spending hours following his subjects through the streets of the city. But this practice had fallen off among Caravaggio's contemporaries, who were far more interested in imitating Michelangelo and Raphael than in rethinking the relation between everyday reality and artistic representation.

To emphasize further his point about his preference for painting street folk over classical statuary, Caravaggio is supposed to have recruited the first Gypsy woman who walked by and brought her back to his quarters, where he painted her in the act of telling a baby-faced young man's fortune—and in the process covertly stealing her unwary client's ring. Still, for all the vehemence with which he insisted on the importance of copying directly from nature without falsification or adornment ("When he came upon someone in town who pleased him," wrote Bellori, "he made no attempt to improve on the creations of nature"), the painter appears to have given nature plenty of help.

Somehow it seems unlikely that the first Gypsy woman he happened to meet would have been quite so beautifully and luxuriously dressed—in a pristine white blouse and turban, cross-stitched in black—as the sly, pink-cheeked, and lovely fortune-teller in his painting. And it seems oddly convenient for the purposes of the narrative that she and her customer are both around the same age and similarly attractive; they even look vaguely alike. Even so, you can observe Caravaggio seeking out the convincing detail, such as the way the handsomely costumed young man has removed only one of

his leather gloves in order to have his palm read. You can imagine the artist watching or asking his model exactly how she would proceed, taking her client's hand in both of hers, tracing the lines with one finger while she gently and provocatively prods the mound beneath his thumb, distracting and transfixing him—a tactile sleight of hand.

The con game is rougher, more raucous, and less sweetly eroticized in *The Cardsharps*, another scene from the low-life demimonde Caravaggio painted at around the same time as *The Gypsy Fortune-teller*. Again the innocent dupe is a well-dressed, prosperous, naive young man, who intently contemplates the cards in his hand as if he were playing a regular, straightforward game of cards. But the viewer knows what the boy does not. Within seconds of looking at the painting, we have grasped the sketchy situation—namely, that the boy's two companions are cheats, in league against him. Peering over his shoulder is an older, bearded, seedy fellow who uses his right hand—in a fingerless glove, which in itself seems to augur no good— to his youthful partner, who faces their victim across a table. The younger swindler is shown in three-quarter view, turned away from us, just enough so that we can see the cards he has concealed behind him, tucked into his striped doublet.

Like *The Gypsy Fortune-teller*, the painting conveys the sense of a con that's been witnessed in action, observed, as it were, from nature—and then choreographed and rearranged to enhance its dramatic appeal. Surely, Caravaggio had plenty of chance to watch people gambling, a popular pastime in his era, indulged in by groups at every level of society. Also both works, especially *The*

Gypsy Fortune-teller, contain visual references that Caravaggio's contemporaries would have recognized as direct allusions to familiar scenes from the theater and from the *commedia dell'arte*.

Meanwhile, the artist's moral sympathies are far from predictable or clear. Except for the older cardsharp, an undeniably shady character, both the victims and their victimizers arouse in us equal measures of sympathy and disapproval. The few images of this sort that preexist Caravaggio, in German and Netherlandish art, are satirical and instructional, and offer improving moral lessons. But most viewers would find it hard to say what, precisely, Caravaggio means us to learn from what we are seeing.

Much later, after his genius was recognized, and after he began to attract disciples and imitators, Caravaggio was known to fly into a rage whenever he felt that someone—for example, Guido Reni—was trying to copy his style. And history has proved how justified he was, because the more imitative and less talented "Caravaggesque" genre painters of petty criminals hoodwinking their unsuspecting prey have partly succeeded in clouding our view of his dazzling originality.

In both *The Cardsharps* and *The Gypsy Fortune-teller*, you can see the pleasure of an artist discovering something new—the sheer fun of fabrics, textures, of meticulously rendering, in two dimensions, the plumes in the feathered caps. You can imagine how satisfied he must have been with these early efforts to dramatize an event, to organize a group of actors in a *mise-en-scène* that today we would call cinematic. And you can watch an artist realizing that what he is doing

is succeeding, that the paint is doing what he wants it to do, that his intention and purpose are finding their way onto the canvas.

And that was what occurred. The paintings furthered their creator's goals, both artistic and professional. Caravaggio found a dealer, whom Baglione identifies as Maestro Valentino. *The Gypsy Fortune-teller* and *The Cardsharps* caught the eye of Cardinal Del Monte, a generous collector and an important figure in the Roman art world, who—coincidentally, or perhaps not so coincidentally—was a great fan of *commedia dell'arte* and had a well-known weakness for gambling.

Born in Venice, raised in the sophisticated court of Urbino, Francesco Maria Del Monte came to Rome around the year of Caravaggio's birth. There he became a confidante of Cardinal Ferdinando de' Medici. When Ferdinando was recalled to Florence to become the grand duke of Tuscany, he helped Del Monte (who became Ferdinando's cultural and political representative in Rome) to advance in the ranks of the ecclesiastical hierarchy. Appointed cardinal, Del Monte moved into the Palazzo Madama, where he lived unostentatiously and focused his energies on a broad range of intellectual and artistic pursuits. He was famous for his love of music and musical instruments; his fascination with science, alchemy, literature, and philosophy; his fondness for the theater and for parties; and for the avidity and single-mindedness with which he collected art. By the time of his death in 1626, he possessed more than six hundred works, including eight canvases by Caravaggio. He was also renowned for

his personal charm, his diplomatic skills, his integrity, his sense of humor, and above all for the enthusiasm with which he enjoyed the worldy entertainments available to a Roman church official with some money and considerable influence.

In 1595, Cardinal Del Monte, who by then had purchased *The Gypsy Fortune-teller* and *The Cardsharps*, invited Caravaggio to live in the Palazzo Madama and to become part of a household that included numerous artists and sculptors, singers and musicians. Bellori remarks on the boost this gave Michelangelo Merisi's confidence and reputation, and surely it must have been a great relief to him to find a stable, congenial living situation and a dependable means of support after the uncertainties of his first years in Rome. Soon the artist was turning out canvases as consciously charming and seductive as *Boy with a Basket of Fruit*, but now geared to the sensibility, tastes, and interests of his munificent new patron.

The first painting that Caravaggio appears to have done expressly for Del Monte was *The Musicians*, also called *A Concert of Youths*, which, according to Baglione, he painted "from nature, very well." The work depicts four boys, each prettier and more adorable than the next, who have come together, presumably in preparation for a concert. In the center of the canvas, a handsome young man in a loose and nearly transparent white blouse, with a length of heavy red brocade draped diagonally across his chest, tunes a lute. He has not begun performing, but already his eyes are brimming with tears. Over his left shoulder, a dark-haired youth who closely resembles the boy with the basket of fruit (both of whom are thought to have been

modeled on Mario Minniti, Caravaggio's Sicilian friend, with whom he may have lived at the Palazzo Madama) holds a shawm—an early wind instrument—as he gazes out at us, attentive and expectant. The two other boys seem unaware of our presence. On the left, a winged Cupid, even younger than his companions, concentrates on separating some green grapes from a bunch, while, on the right, another boy, draped in a white toga tied with a bow, turns his half-naked, beautiful back and the tender nape of his neck to us while he studies a musical score. A violin and bow rest on the bench beside him.

The boys are clothed, it's true, but their flowing white garments are depicted in a way that suggests casual disarray and undress, and manage to reveal enough bare flesh so that they seem effectively naked. Or perhaps that impression is the result of the perfect intimacy, the ease, the relaxation, and above all the air of erotic indolence with which they cluster together to fill the space of the picture. Like the boy with the fruit basket, their pink lips are gently parted, their eyes veiled. We may have watched groups of musicians tuning up and preparing to play, but rarely have we seen any as dreamy, as delectable, or as enticing as these.

Not long afterward, Caravaggio painted the *The Lute Player*, another offering for Del Monte on a musical theme. Here a pretty, curly-haired, dark-eyed, and even more androgynous youth in yet another flowing white shirt stares seductively at us as he plays his lute, an instrument known for its aphrodisiac qualities; many love songs were composed for its particular tonal range. Indeed, the musician's gender is so ambiguous that Bellori describes the work as a portrait of a woman in a blouse playing a lute. It has also been sug-

gested that the model for the painting was the singer Pedro de Montoya, a Spanish *castrato* who was part of Del Monte's household.

In this painting, unlike *The Musicians*, we can read the score from which the boy is singing. It's a madrigal by the sixteenth-century Franco-Flemish composer Jacob Arcadelt, a song whose lyrics say, "You know that I love you." At the left of the canvas is a vase of flowers and an arrangement of ripe and overripe fruits and vegetables, including some figs and a cucumber that viewers of the period would have recognized as a sly sexual joke.

Looking at the musical paintings Caravaggio made for his cardinal and that he intended to gratify the tastes of his new employer, it's all too easy to recall the unfriendly assessment of the Flemish writer Dirck van Amayden, who wrote that, in his youth, Del Monte had had a weakness for women of ill repute, but that, as he grew older, his sexual attentions were directed entirely toward young boys. He was discreet, Amayden continued, until the election of Pope Urban, after which Del Monte became more unrestrained and open in the pursuit of his erotic proclivities. Even when he was elderly, impotent, and nearly blind, his dalliances continued, and near the end of his life he named a boy as a beneficiary in his will.

But why should that surprise us? Rome was, as we have seen, a city in which men greatly outnumbered women and in which men tended to marry at a relatively late age. And the disturbing revelations of our own time have made it painfully clear that even the most pious priests and church officials are not always immune to the stirrings of erotic longing.

Recent scholarship has revealed that homosexual activity was so

common in Renaissance Florence that a special department of the police force, the Office of the Night, was created expressly to deal with "sodomites" who indulged in these forbidden, sacrilegious, and illegal pursuits. During the seventy years, from 1432 to 1502, that the Office of the Night was in operation, 17,000 people (in a city of 40,000) were brought to the office's attention, and 3,000 were convicted of having had homosexual relations. Penalties could be severe, ranging from public whipping and humiliation to prison terms. Rarely, these crimes were punished by mutilation and castration; even more rarely, the convicted man was burned to death or beheaded. In the sixteenth century, the city fathers of Lucca legalized prostitution in the hope that increasing the number of available women might decrease the incidence of sodomy.

Closer to Caravaggio's era, in a town near Assisi, a well-known sodomite was released after merely paying a fine. And according to popular wisdom, the case gave sodomites a free pass to conduct their private lives as they wished.

Perhaps because the dramatic upsurge in Caravaggio's reputation coincided with a period during which our own modern society became radically more open about matters of sexual preference, there has been a remarkable amount of discussion concerning the nature of the artist's sexuality. Though earlier critics hinted strongly at his erotic ambivalence, the artist was first officially "outed" in the early 1970s. In the meantime, anyone who had ever glanced at his work would doubtless have noticed the highly charged, enraptured manner in which he depicted young boys, and his lifelong lack of interest

CARAVAGGIO

(compared, for example, with such artists as Titian) in naked female flesh. The subjects that permitted respectable painters to explore their personal and professional interest in naked women—for example, depictions of Susanna in her bath spied on by the leering elders—failed to seize Caravaggio's imagination, and it's revealing to compare his fully dressed, melancholy, and unusually chaste Magdalene with Titian's luscious, repentant sinner, clothed only in her own flowing hair. Whenever a male and female appear together in Caravaggio's secular paintings, in *The Gypsy Fortune-teller* or in *Judith and Holofernes*, for example, the implications of their connection are unfortunate, even dire: The man is being cheated or killed.

Even so, the debate has raged on. Writing in 1995, one critic argued that Caravaggio's friend and model Mario Minniti could not possibly have been homosexual; the conclusive proof being that, after returning to his native Sicily, he married and had children.

The common thread—and common fallacy—of many of these academic and literary conversations has been a tendency to make assumptions and draw conclusions as if those who lived in previous centuries thought about sexual behavior and sexual identity in the same terms as we do. Perhaps because sexuality seems so instinctive, so deep and inborn, we tend to suppose that its manifestations have remained constant and unchanged. But though we have mostly learned better than to generalize about other cultures from the mores of our own society, we still make the mistake of assuming that our ancestors experienced love and lust as we do, centuries later.

In fact the modern categories that divide the heterosexual from

43

the homosexual and place the bisexual on the margins of both groups are relatively recent. Sex between men in Caravaggio's time was viewed very differently than it is today. For one thing, homosexual activity seems not only to have been common but, despite its illegality, less stigmatized and shameful than we might suppose.

It was widely understood and accepted that a man could have sex with both males and females at different stages in his life. Moreover, sex with another male was not associated with effeminacy, nor was it believed to compromise one's toughness or masculinity, especially if one took the active role, and *only* with the appropriate partner, which is to say with a boy, preferably smooth-skinned and beardless, and no older than eighteen. The social pressures concerning the requisite age discrepancy, and the attendant taboos involved, were so unwavering and so strict that they seem to have permeated and governed the most basic rules of attraction and desire. Sex between two adult males was considered so shameful and rare that only a few instances of it were uncovered by the effective and nosy police who compiled the informative annals of the Office of the Night.

All this influences our ideas about Caravaggio's erotic life. The fact that he might have been sexually involved with Mario Minniti and later with the prostitutes whose names we know as Fillide and Lena, would have presented, in his own era, not the slightest contradiction. Nor would it have seemed perplexing that a confirmed sodomite was also an aggressive brawler, a street tough, and a murderer. Finally, and perhaps most interestingly, by the time Caravaggio came to Rome, he was already near or past the upper limit at which

he might have been considered a desirable or even permissible object for the sexual attentions of an older, more powerful man. And so, though it is sometimes implied that Cardinal Del Monte's interest in Caravaggio and his welcoming the painter into his home had a sexual component, it is far less likely they would have shared the same bed than that they would have shared an attraction to younger boys—the very sort of boys whom Caravaggio painted.

For the next few years, Caravaggio continued to live in the Palazzo Madama, supported by Cardinal Del Monte, who had become the director of the artists' guild, the Accademia di San Luca, and who introduced Caravaggio to prominent cultural figures and art collectors—among them, Cardinal Federico Borromeo, Cardinal Alessandro Montalto, the banker Ottavio Costa, and the Marchese Vincenzo Giustiniani, who became one of Caravaggio's most important patrons and supporters. Quite a few of these men, who made up Del Monte's social circle, would later order and purchase work from Caravaggio, and they helped him obtain the major commissions that would transform him from a gifted artist into a great one.

Most of what we know about Caravaggio's relatively tranquil and untroubled early years with Del Monte can be inferred from what he painted—works in which he experimented with novel ideas, set off in new directions, and showed off the virtuosic skill he had already developed. What comes through in the paintings of this period is a lightheartedness and ease, the relaxation—that is, if we could imagine Caravaggio "relaxing"—of an artist who at long last knows where

his next meal is coming from and that he will, at least in the near future, have a roof over his head.

Throughout this time, he was painting what his patrons asked him to paint and what he imagined they wanted him to paint. Still, he was insisting on his right to exercise his uncompromised and uncompromising genius and his theories about art. The canvases of this period seem wholly sincere and at the same time ironic, like private jokes on the subject of the artistic conventions that he was being encouraged to follow. Such contradictions may be part of the reason why even these—the most apparently "old-fashioned" of his works— still strike us as so modern. Whatever unease we may feel with these traditional themes and conventions, Caravaggio feels it also, along with us and *for* us—preemptively, so to speak—and his work at once celebrates, gently mocks, and transcends the subject matter (the portrait of the mythological figure, the sentimental religious scene) that, handled by a less original painter, can sometimes fail to translate across the intervening centuries.

The rendering of beauty together with the simultaneous joke about beauty is at the heart of Caravaggio's only surviving still life, *The Basket of Fruit*, which Del Monte's friend Cardinal Federico Borromeo is thought to have commissioned from Caravaggio, or possibly to have received as a gift from Del Monte. An ardent fan of still lifes in general and of Northern art in particular, Borromeo collected the work of Jan Breughel, who painted exuberant, splashy studies of glorious floral arrangements in which each showpiece tulip, iris, or peony is an honor to its species.

Anyone could have predicted that Caravaggio would have been unlikely to do anything of the sort, and in fact his painting can be seen as a kind of challenge to the vibrant bouquets of his Northern contemporaries. His still life is another avowal of his belief in painting from nature and at the same time making his audience aware that they are looking at a painting. It is also rebellious rejection and refutation of the months during which he toiled as the (no doubt underpaid) flower-and-fruit man in Cesari's studio.

Nearly every fruit in Caravaggio's basket looks as if it has spent too long on the vine or on the ground in the orchard. The pear is speckled with brown spots, the figs have begun to split, and no one has even bothered to turn the apple around so that the wormhole won't show in the painting. The leaves are in even worse condition, half wilted and autumnal, or disfigured by dry, discolored patches, frayed edges, and the ragged gnawings of insects. The water droplets sprinkled about only serve to make us aware that the fruit is anything but dewy or fresh.

Breughel's flowers seem to want to explode out of the painting, but Caravaggio's fruits rest heavily on the woven straw basket, each piece weighing on the other. Nothing, we'd think, could be more "real" than these decidedly unidealized fruits, and yet at the same time the artist is continually subverting our sense of reality. The grapevine on the right rises on a diagonal, countermanding the laws of gravity. The leaves and branches are attached to the fruits in ways we can't remember ever having seen. The only shadow in the painting is cast by the base of the basket, which hangs over the ledge on

which it is set, and which seems to project into some disorienting dimension between us and the subject of the painting.

The relation of the fruit basket to its flat, golden, shadowless background reminds us of the fantastic, unreal space of ancient Roman wall painting, and of how the saints and Madonnas seem pasted onto the gilded panels of early Lombard and Sienese paintings. The effect is almost as if Caravaggio set out to paint a Netherlandish still life and wound up doing something utterly Italian, entirely his own, and far more compelling than anything that might have resulted from having done the expected. Except perhaps for the most committed botanist or serious student of Northern art, it's hard to spend very much time in front of a Jan Breughel painting. The magnificence of each flower and of the overall arrangement can be grasped within seconds. By contrast, the strangeness and originality of Caravaggio's still life reveals itself in stages, and can command our attention, our fascination, for hours.

If the pears and apples in *The Basket of Fruit* seem slightly beyond their prime, the fruit in *Bacchus* has progressed considerably further in the direction of outright rot. It's almost as if the painter had, on completing the still life, stored the fruit basket in a closet and brought it out later to adorn the table of his pleasure-loving god of wine. Of course, Bacchus is associated with autumn and the harvest, which would make the fruit appropriately past season, and yet you can't help thinking that a god could, if he wished, find it in his divine power to offer us something more appetizing than a wormy apple, a rotten peach, and a burst pomegranate.

The whole painting is full of humorous touches and clever contradictions. Yet though many critics have applied themselves to unraveling its allegorical nature as a parable on the theme of short-lived love and fleeting youth, few seem to have noticed how witty it is. Perhaps it's too perplexing to imagine that someone as aggressive and tormented as Caravaggio could have had a sense of humor.

But surely the painter must have noticed that his adorably fleshy young god—another heavy-lidded, dark-eyed, smooth-skinned, curly-haired vision of Mario Minniti, half reclining on a Roman couch draped in a white cloth that could be a continuation of Bacchus's revealing toga—makes no effort to hide a set of unmistakably dirty fingernails. The daintiness with which he holds his wine glass emphasizes the griminess of the fingers with which he grasps it, just as the smooth plumpness of his flesh and the outrageous campiness of his grape-leaf headdress contrasts with the muscularity of his biceps. His face and hands are as red as those of the *Sick Bacchus* were green, and though his seductive eyes meet ours as he gazes out of the canvas, it's his gorgeous rounded shoulder that the light of the painting wants us to admire.

Bacchus represents one of the last times that one of Caravaggio's limpid, half-naked pretty boys would stare seductively at us, inviting us to contemplate and, if only we could, touch the living, embodiment of sheer carnal perfection. From now on, when Caravaggio found it impossible to resist the urge to paint—or the popular demand for—such subjects, the assumption would be that the lovely boy was the young Saint John the Baptist. The ironic touches and the

excessiveness of the *Bacchus* was perhaps a signal that its creator had explored the limits of the magic that paintings like this could work on Del Monte and his circle. By then such depictions may have come to seem too easy, and Caravaggio, like any great artist, was in all likelihood growing restive with the work he could do with practiced assurance but without any particular sense of discovery or challenge.

And so we can watch him cautiously testing his own limits, as well as the boundaries of what he would be permitted to do by the rarified circles in which he moved. In two of the paintings he completed at the time—*Boy Bitten by a Lizard* and *Medusa*—he moved from the alluring and the charming to the grotesque and the extreme. Both works are animated by violence, not violent action so much as the dramatic and sudden response to violence. We can only speculate about what a relief it must have been for Caravaggio to edge toward a mode of expressing an element that must (whether buried or overt) already have been present in his personality.

Boy Bittten by a Lizard is, like *Bacchus*, a bit of a joke. The lizard that has emerged from an arrangement of fruit to bite the boy on the finger has a sexual connotation that's hard to overlook, even for those reluctant to mine art for its symbolic content. This association has followed the tiny reptile from Caravaggio's time (when poems explicitly made the connection between the lizard and the male sexual organ) to our own, when boys sometimes refer to urinating as "draining the lizard."

The drapery and the sweet, exposed shoulder of the child in the painting recall the boys in *The Musicians* and the *Boy with the Basket*

of Fruit, but this one is as distraught and disturbing as those youths are placid and appealing. Perhaps it's because—with that little rose tucked behind his ear, with those delicate hands and wrists—he's taken androgyny to the point of effeminacy, a quality that Caravaggio's culture found less sympathetic and attractive. There is nothing manly in the terror with which he's reacting to an injury which, however painful, most be minor. And there's a staginess, a theatricality in his turning toward us. Why isn't he looking down at the lizard, or at his hand?

Regardless of the smooth, bare shoulder that so often telegraphs Caravaggio's code for erotic attraction, the boy's carnal appeal interests the painter far less than the electric intensity of his startled reaction. The boy could be a study for the terrified youth who, though no fault of his own, is forced to witness Saint Matthew's brutal murder on the steps of the altar. The difference is that, unlike the lizard's victim, the boy in *The Martyrdom of Saint Matthew* is responding to something momentous and life-changing.

What's striking about Caravaggio's great religious paintings is that the contorted expressions he practiced in these earlier efforts were later reserved entirely for those who watch the horrors, rather than those who experience the torture and humiliation and who endure their sufferings with humility and stoic patience. Perhaps one of the things that Caravaggio learned from *Boy Bitten by a Lizard* was that fear and pain stir our sympathies less than courage and forbearance do.

Like *Boy Bitten by a Lizard*, Caravaggio's *Medusa* can be seen as

an experiment in the representation of facial contortion. Feared for her ability to turn men into stone with a glance, the Gorgon with her headdress of living serpents was killed by Perseus, who realized that Medusa could be vanquished by tricking her into looking in a mirror and giving her, so to speak, a dose of her own medicine. Paralyzed by the sight of herself, the suddenly vulnerable Gorgon was swiftly beheaded by Perseus.

The brilliance of the Greek hero's approach would have appealed to Del Monte and his circle, who were fascinated by natural wonders, logical puzzles, scientific solutions—and also by mirrors. In one of Caravaggio's paintings from around the same time, *The Conversion of the Magdalene*, the saint's hand rests lightly on a dark convex mirror so large that, at first glance, it looks like a shield. Echoing this association between the mirror and the shield and compounding the paradox of the monster undone by her own monstrous apparition, Caravaggio painted the Gorgon's head on canvas attached to a convex wooden shield. But the portrait is rendered in such a way that the image appears to be concave. Like Perseus, Caravaggio captured the Gorgon at the moment of defeat and death. Jagged spikes of blood stream from the base of her severed head. Her mouth forms an oval of fear and shock, her eyes bulge from their sockets, as the painter succeeds in conveying the impression of a paralysis that is only a few moments old. Even the knotted serpents seem to have newly ceased their twisting and writhing.

This example of virtuosity, this show-offy tour de force was the perfect present for Del Monte to bring to Florence, for the Grand

Duke Ferdinando de' Medici—who shared the cardinal's interest in science, optics, and alchemical explorations—to add to his collection of arcane and unusual armor. The work provided an opportunity for Del Monte to display the bravado, the technique, and the mastery of his new favorite painter, while it enabled Caravaggio to make his own contribution to a long and venerable tradition of shields decorated with the decapitated heads of the Medusa, images that were superstitiously half believed to turn the Gorgon's evil spell against the enemy.

One such shield, by Leonardo da Vinci, was in the collection of Duke Cosimo de' Medici. Another appeared in a painting by Andrea Mantegna. But neither of these attained quite the level of animated hideousness that Caravaggio reached, nor did they suggest the play of the concave and convex, the magical effects that could be achieved with mirrors, or the nightmare that might await anyone foolhardy enough to gaze too long in the glass. This last theme must have stayed on Caravaggio's mind, since, several years later, he would paint an image of Narcissus, mythology's most unfortunate mirror gazer.

For all their beauty and dazzling skill, works like *The Basket of Fruit*, *Bacchus*, *Medusa*, and *Boy Bitten by a Lizard* seem, in comparison with the masterpieces that Caravaggio would soon begin to paint, a bit like piano exercises performed by a musical genius. Perhaps we're just responding to the persuasive whispers of retrospect, but we can't help feeling that Caravaggio was contentedly biding his time, that

he was (to extend the musical metaphor) vamping while he waited for his cue to begin the real performance.

Under Pope Clement VIII, ecclesiastical fortunes and huge infusions of energy were being expended on making Rome's churches ever more glorious and ornate. The pope took on the task of completing Saint Peter's, and in 1603, his favorite artist, Cesari—Caravaggio's former employer—was hired to design the mosaics for the inside of the dome. Cesari had already painted the fresco of Christ's ascension in the Cathedral of Saint John Lateran, where Giovanni and Cherubino Alberti had frescoed the vaulted ceilings in the sacristy; they were later employed to paint the Sala Clementina, a grand audience hall in the Vatican.

It must have galled Caravaggio to see inferior talents like Cesari creating majestic altars while he was still producing teenage lutenists for the cardinal and his friends. But wisely, he waited and bided his time, meanwhile embarking on a series of religious paintings that combined the time-tested elements proven to please Del Monte—music, half-naked boys, references to Netherlandish still life and Venetian art—with subject matter that reached for an audience wider than a small coterie of cultivated older men. Perhaps, in depicting the Magdalene, Caravaggio was trying to transform himself, and the way in which he was perceived, from a portrayer of grifters into a painter of saints—fittingly, in this case, the patron saint of prostitutes.

It's not hard to believe what Bellori says about Caravaggio's *Penitent Magdalene*—that its subject was yet another neighborhood girl

whose appearance, like those of the Gypsy fortune-teller, appealed
to the artist. He painted her seated, drying her hair, her hands folded
in her lap, dressed in ordinary street clothes, surrounded by a jar of
oil, a necklace of pearls, and some jewels—and pretended, for his
purposes, that she was the former prostitute known for washing
Jesus's feet with her hair. Again it's worth noting that other painters
used the subject of the Magdalene as an occasion for portraying lots
of repentant, naked female flesh barely concealed by the saint's flow-
ing hair. This was precisely the sort of picture in which Caravaggio
displayed scant interest. And yet the most striking thing about Cara-
vaggio's Magdalene was not the artist's lack of lascivious admiration
for his subject but rather the intensity of his compassion and pro-
tectiveness toward the remorseful young woman. At a time when the
pope and the church were instituting increasingly punitive measures
against prostitution, Caravaggio's portrayal is utterly free of moral-
ism or moral judgment; his subject displays not the slightest trace of
criminality, lewdness, hardness, or vulgarity. You feel that this was a
woman he knew, someone whose essential sweetness—and plight—
touched him deeply.

Prostitutes would play a major role in Caravaggio's work and in
his private life. Many of the street brawls in which he participated
were sparked by quarrels over the honor and the affections of
celebrity courtesans such as Fillide Melandroni, who modeled for
several of his paintings, and who is believed to have been somehow
connected with the dispute that would lead to the murder in which
Caravaggio was involved.

The same model who sat for the Magdalene makes another appearance as the Madonna in *The Rest on the Flight into Egypt*, a portrayal of the Holy Family pausing during their arduous journey. Dividing the canvas straight down the middle is the back of a graceful young angel whose pretty blond curls contrast sharply with a pair of darkly feathered wings. The angel's buttocks are barely covered by a wisp of translucent white drapery as he plays, on a violin, a Flemish motet for the Virgin Mary with lyrics from The Song of Songs, which we know because the elderly, bearded Saint Joseph thoughtfully holds the score so that we can read it over the angel's shoulder.

On the other side of the angel, the lovely red-haired Mary sweetly rests her cheek on the head of the plump, slumbering baby she cradles against her breast. Behind them stands a mournful donkey, amid one of the only landscapes Caravaggio is known to have painted, its leafy trees rendered in the botanically detailed yet dreamlike style of Netherlandish or Lombard art. It's all very much to Del Monte's taste: the music, the landscape, the boy. And it somehow manages to more or less successfully press the homoerotic and the hedonistic into the service of the spiritual and the religious.

Meanwhile, from the left of the painting, something marvelous and new is emerging, or preparing to emerge, from an area of darkness, from the donkey's obsidian eye and Saint Joseph's homespun robe. It's Joseph who most compels us with his weariness and weight, his graying beard and unkempt hair, with the compassionate fixity of his gaze and the furrows beneath his receded hairline. He's a very different sort of holy man from the Saint Francis who faints in the

arms of yet another barely clothed angel in *The Ecstasy of Saint Francis*, another canvas that Caravaggio painted for Del Monte. Though older and more hirsute than the angel who supports him, Saint Francis is darkly handsome, with chiseled, youthful features. But the Saint Joseph resting from his journey has not been young for a very long time, and never will be again.

If critics read some of Caravaggio's early works—*The Basket of Fruit* and *Boy with a Basket of Fruit*, for example—as allegories on the cruel speed with which age and mortality overtake youth and beauty, Saint Joseph is the living proof of that cruelty, yanked out from behind the safety of the symbol and the allegorical mask. No one remotely resembling him had yet appeared in Caravaggio's work, but we will see more and more of him as, over the next few years, the artist trades seduction and charm for complexity, power, and greatness. The violin-playing angel may be the official celestial messenger, but it is Saint Joseph who is the harbinger of what is to come as Caravaggio exchanges loyalty to his patrons for loyalty to the truth, and as he finds the courage to portray what is not yet fully present in the painting, and what at the same time matters most: the dust and grit, the wear and tear of Saint Joseph's journey.

Soon enough, Caravaggio would be offered the chance to convey his profound and unblinking vision of that painful, complex truth. Through Del Monte's influence, he was commissioned to decorate the walls of the Contarelli Chapel in the French national church of Rome, San Luigi dei Francesi.

By the time he took on the assignment, the painting of the chapel had been the cause of decades of political wrangling, false starts, failures, broken contracts, and delays. The last artist responsible for the completion of the chapel was none other than Caravaggio's former boss, Giuseppe Cesari, who finished the undistinguished vaulted ceiling, and then—busy traveling with the pope and renovating Saint John Lateran—lost interest in this relatively humble venue, which was unlikely to advance his career. At that point, the priests of San Luigi were understandably willing to hire a relatively untried artist with no experience painting churches, but with a strong reputation and the backing of a powerful cardinal.

In the summer of 1599, Caravaggio signed a contract to paint the side walls of the chapel for the same fee that had been promised to Cesari. The work was to be completed in six months, by the end of the year, presumably in anticipation of the crowds of pilgrims who would be flocking to Rome for the Holy Year of 1600.

Just as the angel divides the *The Rest on the Flight into Egypt* into two opposing realms of light and shadow, male and female, infancy and old age, so its creator straddled two irreconcilable worlds, and his survival depended on his instinct for negotiating the perilous chasm between them. As soon as Caravaggio left his rooms in the Palazzo Madama and stepped outside the sheltered, genteel milieu of Del Monte's circle, he flung himself into the roiling, ongoing dramas of insult, grudge, and violence that moved from the taverns to the whorehouses and spilled out into the street.

Another artist might have let the comfort and security of a generous, dependable patronage lull him into a life of gentility and refinement. But Michelangelo Merisi fled in the opposite direction. Perhaps the pressures and politesse of all those formal musical evenings at the cardinal's palace served to increase the eruptive force with which Caravaggio and his friends—including the painters Prospero Orsi and Orazio Gentileschi, the architect Onorio Longhi, and the art dealer Constantino Spata—exploded into the dark alleyways of the Campo Marzio.

Caravaggio's reputation for disputatiousness grew along with the fame of his work. His early biographers seem to delight in finding the perfect adjectives—*sarcastic, arrogant, quarrelsome, dissolute, tempestuous, restless, peculiar*—with which to express the general low opinion of his temperament and moral character. According to Baglione, he was dismissive and contemptuous of his fellow painters and was always on the lookout for occasions to break his own neck and endanger the lives of others. Bellori claims that, after spending some time in his studio, Caravaggio would arm himself and take to the streets, swaggering like a professional swordsman. Mancini claims that Caravaggio's excessive behavior shortened his life by a decade, while Sandrart mentions the perpetual quarrels engaged in by Caravaggio and his friends, men whose self-consciously romantic motto was "Without hope, without fear."

Van Mander writes that after working two weeks, the artist would spend months going from ball court to ball court, armed, accompanied by a servant, and looking for a fight. When van Mander

published this observation in 1604, Caravaggio's reputation had spread as far as the Netherlands, and the Dutch biographer was writing him without ever having seen his paintings.

Around the same time that Caravaggio's popularity—and the prices he was able to command for his work—were increasing in proportion to the ingeniousness and the power of his art, his name was beginning to turn up in the Roman police and court records. In the first of these cases, in 1597, he appears to have been an innocent witness to an assault on a barber's apprentice. Still, the testimony makes it clear that Caravaggio rarely ventured outdoors without his sword. The next year he was arrested in the Piazza Navona for carrying weapons without a license.

Indeed, the more celebrated he became, the more brutishly he behaved. Less than six months after the paintings in the Contarelli Chapel were unveiled, the records show him in trouble with the law again, this time for attacking an art student with a cudgel and a sword. And from the turn of the century on, the complaints become more frequent, and the incidents grow more violent and more disturbing.

But in that eventful Holy Year of 1600, the city and church officials had so much scandal, discord, and disaster to contend with that the charges brought against a certain Michelangelo Merisi da Caravaggio must have seemed very minor and inconsequential.

The population had barely recovered from the catastrophic flood that, in December 1598, swept over the banks of the Tiber and inundated the city as far as the Piazza di Spagna, destroying the bridge of Santa Maria, and leaving the ruin now known as the Ponte Rotto.

Before the river finally receded, it had filled the churches, washed the dead from their graves, ruined the food supply, and killed fourteen hundred people. Nor had the city entirely emerged from under the cloud of sympathetic grief that had collected around the public execution of the beautiful Beatrice Cenci, imprisoned and tried—along with her stepmother, Lucrezia; her brother, Giacomo; and the bailiff of the gloomy family fortress in the mountains of the Abruzzi—for conspiring to murder Beatrice's heartless and abusive father, Francesco.

Early in 1599 Beatrice, Lucrezia, and Giacomo were arrested; the bailiff died under the torture that served as his interrogation. And on September 11, the Cencis were executed. Wrapped in a black veil, Lucrezia was beheaded first. Giacomo was drawn and quartered. Even by the standards of the day, Beatrice's death was horrific. Recoiling from the executioner, the proud girl placed her own head beneath the ax, where she waited for an unimaginably long time while Clement VIII, who had refused to pardon her, finally granted her absolution. That good news—though she would still be executed, she would not be damned—was brought from the Vatican to the Piazza di Ponte Sant'Angelo. Frightened and restless, Beatrice lifted her head and almost stood, then knelt again as soon as the pope was heard from. The force of the blow made her body rear up as her head rolled away, and, as a final indignity, the monks dropped her corpse from the platform as they settled her into her coffin.

The execution was well attended. It has been suggested, persuasively, that contemporary artists were among the witnesses, and that

the horror of the beheadings seeped into Caravaggio's *Judith and Holofernes*, which was completed around that time.

Painted for the Genoese financier Ottavio Costa, Caravaggio's rendering of the biblical scene cuts straight to the climactic moment at which the brave Jewish widow saves her people by killing the Assyrian general as he lies drunk in bed. It's not one of Caravaggio's most affecting works, partly because we feel that he has only a cerebral or formal interest in his subject. In his scenes of violence, or of the aftermath of violence, Caravaggio moves us most deeply when he can enlist our sympathies on the side of the victim—the nobly suffering Saint Peter or the fragile, martyred Saint Lucy. But here the victim is also the villain. Judith is the heroine, Holofernes' death is divinely sanctioned, which may be why we intuit something slightly off center and forced in this otherwise compelling image.

There's a faintly distasteful sexuality in the general's naked muscular writhings, the blade just slicing through the neck, the spurting blood that looks more like blood in a painting—indeed, like red paint—than like blood in "real life." And the nipples visibly hardening under Judith's white blouse do little to decrease our sense that we are being shown something far more unsavory than a mere murder. Judith seems to share this distaste, as—observed by a bronzed crone who evokes Leonardo's sketches of geriatric grotesques—she performs her odious task at arm's length and with the repelled determination of a schoolgirl dissecting a frog.

Yet despite its shortcomings, *Judith and Holofernes* marks a major watershed, a sea change in its creator's vision. His first study of sen-

sational violence is also the first work in which a small and theatrically lit cast is posed against a nearly black, almost featureless background, empty but for the furled bloodred cloth that will keep reappearing in his work, above *The Death of the Virgin*, and half covering the dying Saint John in yet another beheading, this one in the Co-Cathedral of Saint John on the island of Malta.

It may well be that poor Beatrice Cenci's ghost hovered over the burly, struggling, partly decapitated Holofernes, though it's just as likely that the success of Caravaggio's *Medusa* inspired him to try his hand at another subject involving beheading, blood, homicide, and the instant of death. Surely the artist must have had plenty of opportunity to observe random killing and ceremonial execution, in art as well as life.

For decades, decapitation—along with all manner of grisly and ingenious methods of achieving martyrdom and imposing it on others—had been a hugely popular and rich vein of creative inspiration, encouraged by the cult of martyrdom that swept through the church during the sixteenth century. Around the inside wall of Rome's round church of Santo Stefano Rotondo is a kind of baroque cyclorama, a cylindrical fresco in sections, each depicting one or more saints in the process of being dismembered, boiled in oil, stabbed, beaten, burned, fed to the lions, and so forth—all painted with an ineptitude and cartoonlike childish glee that makes the effect of the whole all that much more loathsome and disturbing.

However chilling we may find them, the sorry fates of the martyrs were among the inspiriting images that spiked the Jubilee fever

of the pilgrims who converged on Rome in 1600. During a Holy Year, which occurs every quarter century—the last was in 2000—the faithful who reach Rome are rewarded by a chance to have every last sin washed away and to return home with souls as clean as those of freshly baptized babies. In solidarity with the three million travelers who arrived in Rome that year, Clement VIII wept copious tears as he made his weekly barefoot visits to the major basilicas, washed the feet of the pilgrims, and invited twelve of them to eat daily at his table. He was notably less generous to the Protestants, Jews, and assorted heretics who were publicly executed and tortured during his pontificate. Perhaps the most famous of these was Giordano Bruno, who—for the crime of refusing to recant his views on morality, cosmology, and the nature of the universe—was led out, naked and muzzled to prevent him from denouncing his tormentors, and burned at the stake, on February 17, in the Campo de' Fiori.

This, then, was the society—violent and intemperate, suffused by the specter of disaster and the spectacle of merciless death, trafficking in empty promises of salvation without hope, of redemption without a sign of where redemption might be found, of dispensations reduced to the price of an arduous journey—in which Caravaggio lived. And this was the world he brought with him as he contemplated the bare walls of the Contarelli Chapel and tried to imagine how he could put everything he believed about art and human nature, everything he had seen and learned and suffered, into two widely separated and resonant moments from the life and death of Saint Matthew.

* * *

By all accounts, including the mute but incontrovertible testimony of the X-rays that reveal the various versions and revisions of the Contarelli paintings, Caravaggio did not have an easy time of it. To begin with, Cardinal Mathieu Cointrel, or Matteo Contarelli, who had endowed the chapel and died years before Caravaggio was hired to complete it, left a series of elaborate directions as a sort of addendum to the contracts with the earlier artists who had been commissioned to carry out what the French cardinal had in mind. His plans included, first, a scene of Saint Matthew in his countinghouse, dressed for business and surrounded by the tools of the tax collector's trade. These specifications stated that Matthew should be rising from his desk and going out into the street, from which Christ— who had been passing by with a group of his disciples—had called to him and summoned him from his old life into a new existence.

The cardinal's vision of how Matthew's martyrdom should look was even more detailed. The scene should be set in a temple, which should include an altar with from three to five steps. Matthew was to be shown in the process of being murdered by a group of soldiers, assassinated while celebrating mass, depicted at the very moment at which he had just been wounded and had fallen, or was falling but was not yet dead. And all this was to be observed by a crowd of men, women, and children, old and young, each one responding to the tragedy with pity, terror, and disgust.

With characterisitic bravado, Caravaggio began with the more challenging and complex scene of the martyrdom—and almost

immediately ran into trouble. Perhaps the cardinal's emphasis on the design of the temple pressured or guided the painter into designing an early version in which the figures were dwarfed, and frozen in place, by the architectural grandeur of their surroundings. Marching in, with his sword drawn, from the left of the composition, the executioner looks more like a warrior in a processional on a Greek vase than the simultaneously frenzied and purposeful hands-on assassin who would appear in the finished work.

In another attempt, Caravaggio modeled his composition after Raphael and focused on the crowd and its response—a woman who has raised her hand to her face, a little boy slipping beween the legs of a soldier who turns his back to us and bisects the painting much as the angel did in *The Rest on the Flight into Egypt*. But the static, stopped-time quality of *The Rest on the Flight into Egypt* was not what Caravaggio wanted, and so he left off work on the martyrdom and turned to the less crowded and turbulent scene in which Matthew is extracted from the countinghouse and transformed into the messenger of a new religion.

In *The Calling of Saint Matthew*, we can see Caravaggio finding the inspiration and the courage to reinvent history and tradition by returning to the stark simplicity of the Gospels, to reimagine an iconic text according to his own experience, to bring the sacred down from the realm of the eternal and the ethereal into the temporal and earthly, and to exchange his contemporaries' fantasy of how the world looked in Jesus's era for the observable reality of his own surroundings and his own time. The scene in Matthew's countinghouse

recalls *The Cardsharps*. More boys in plumed hats and striped dou-
blets are gathered around yet another table again for reasons involv-
ing money, though their business is less obviously suspect. It's almost
as if Caravaggio realized that the solution to his dilemma was to pic-
ture Jesus appearing to the con men in the earlier painting. And the
grifters' stupefaction could hardly have been more intense than that
of Saint Matthew, whose hand has already become a continuation of
Jesus's hand, as he points to himself, one finger extended, in uncon-
scious mimicry of the gesture Christ makes, pointing to him.

What Caravaggio seems to have learned in the process of paint-
ing *The Calling of Saint Matthew* is the central importance of the
human drama, of a psychological moment, and the way in which an
event can be intensified by individualizing, rather than generalizing,
the players who enact it. The generic saints of mannerist art have
been replaced by a specific man, a recognizable portrait from nature,
from life, a human being whose wonder and whose understandable
concern affect us more than we could have been moved by a figure
who looks like a saint in a painting—which is to say, like no one we
know.

Even more consequential was Caravaggio's new understanding of
the critical difference between actor and bystander, between protag-
onist and supporting cast. Everything important in *The Calling of
Saint Matthew* is transpiring in the highly charged and magnetized
space between Jesus and his new disciple, and every trick the artist
knows—the use of light and darkness, of proportion and composi-
tion—is being deployed to fix our attention on the sudden, vibrant

connection between them. The boys in their brightly striped costumes and the old man in his spectacles serve as our stand-ins. Their presence, their importance, their extraneousness, and their efforts to understand or ignore what is happening before their eyes parallel the momentary shifts and readjustments in *our* reactions to this simultaneously comprehensible and ineffable narrative of the miraculous.

And that is what made all the difference when Caravaggio again took up his attempt to depict the apostle's death. He stopped trying to set the murder in a Raphaelesque *stanza* and imagined it occurring in a Roman alley disguised as an early Christian temple. The woman in the previous draft has disappeared from the crowd, in which there is no longer anything female or pliant to soften the blow of what is occurring. The killing unleashes the chaos, the confusion, and the cyclonic turmoil of random street violence, except that it isn't random. The assassin knows exactly what he's doing. His costume— like many of the onlookers, he is naked but for a loincloth—suggests that he has pretended to be one of the newly converted Christians waiting to be baptized, and that he has risen up from their midst to carry out his mission. Matthew knows him, they are not strangers, and now they are playing out this final act together.

The killer and the elderly saint (who resembles Joseph in *The Rest on the Flight into Egypt*) have become the sinister mirror image of the younger Matthew being summoned by Christ. Again, their gazes are locked; no one exists for one but the other. Their connection is the center, the eye around which the hurricane swirls, and the killer's rough grabbing of Matthew's wrist is the final turn in the

story of Jesus seizing and claiming Matthew's life. Here the point of contact is the body instead of the soul, and therefore the meaning is clear enough so that everyone understands. In falling, the saint has almost struck a boy, who twists away, open-mouthed, screaming.

In the far background is Michelangelo Merisi da Caravaggio, his face drawn by horror and grief, aged years beyond the pretty youths he painted for Del Monte. He has done more or less what Matteo Contarelli asked, but in doing so he has created something the cardinal never imagined, something distressing and new, a vision glimpsed from the edge of an abyss from which Caravaggio will never, after this, be able to pull back.

Considerably after the time specified by his contract, he finished the Contarelli paintings, and though the date of their installation is uncertain, he was paid in July 1600, a fact that suggests that they had been completed. They were definitely in place by the end of the Holy Year, when a carpenter submitted the first of a series of invoices for his work on the final installation and framing. By then Caravaggio's fame had skyrocketed, and he had begun to receive lucrative commissions for large and ambitious paintings.

Baglione notes that spiteful people praised his work to excess and goes on to relate how Federico Zuccaro, the celebrated painter and darling of the art establishment, remarked that he failed to see what all the commotion was about, since *The Calling of Saint Matthew* offered nothing new, nothing that Giorgione hadn't already done before. Bellori observes that even though Caravaggio redid the painting twice over, the composition and the animation

of *The Marytrdom of Saint Matthew* failed to do justice to the biblical story, and anyway, he remarks, both Contarelli paintings were difficult to see because of the dimness of the chapel, and because the paintings themselves were so dark. In addition, he tells us that though the younger painters were so impressed by Caravaggio's ingenuity and skill in imitating nature that they tried to copy his method—finding their models in the street and lighting them from above—the old guard took every opportunity to criticize him, claiming that he was unable to come out of the cellar, that he lacked imagination and refinement, and that his technical limitations obliged him to paint all his figures in one light, and on a single flat plane.

Many of Caravaggio's contemporaries had a more positive opinion of his achievement, and in September 1600, he signed a contract with the pope's treasurer-general, Tiberio Cerasi, to paint *The Mystery of the Conversion of Saint Paul* and *The Martyrdom of Saint Peter* for the Cerasi family chapel in the church of Santa Maria del Popolo. The work was supposed to be finished in eight months, and the artist agreed to show Cerasi preliminary plans that would make clear how he meant to depict the mystery and the martyrdom.

Once again, regardless of whatever Caravaggio may have learned from his labors on the Contarelli paintings, the execution was far more difficult than he could have anticipated. His first attempts were, like the first versions of Matthew's martyrdom, failures. This time, Caravaggio finished the paintings only to have them rejected, either by Cerasi or by the Fathers of the Madonna della Consolazione, who assumed control of the chapel's decoration after Cerasi's

death in May 1601. Caravaggio may have been handicapped by his own most recent artistic and popular success, by the satisfaction of having discovered how to capture the swirling violence and turbulence of Saint Matthew's murder. Or perhaps the famously competitive artist's difficulties may have had something to do with the fact that Annibale Carracci's dynamic, if relatively conventional, altarpiece *The Assumption of the Virgin* was already in place.

By then, Caravaggio and Carracci were considered to be serious competitors, and their simultaneous work on the Cerasi Chapel was seen as the artistic equivalent of an athletic contest. Carracci was one of the only contemporary painters whose work the notoriously critical Caravaggio admired, as he mentioned in his testimony at the libel trial. And it was said that he liked Carracci's painting of Saint Margaret in the Church of Santa Caterina dei Funerari so much that he "died over it."

But the likeliest explanation for Caravaggio's difficulties is that his problem had less to do with Carracci than with the dramatic (or, more accurately, undramatic) nature of the narrative itself. On the way to Damascus, Saul, a soldier authorized to continue his vicious persecution of the Christians, was intercepted by a blinding light that knocked him to the ground. There he had a vision of Jesus, who told him to rise and proceed to the city and wait there for further instruction. The most significant action in the story is interior, and transpires within the heart and soul of an unconscious man lying stunned and motionless in the road. Doubtless that is why the detail of Paul having been thrown from his horse—an element notably

absent from the New Testament account—was required and supplied by the demands of visual art.

In earlier depictions, such as Raphael's and Michelangelo's, the event involves a crowd and a large amount of human, military, divine, and equine participation. Both versions feature Christ skimming down from heaven to reveal himself to Paul; in Michelangelo, this visitation is accompanied by a small army of angels.

Caravaggio's first attempt—which survives in Rome's Odescalchi collection—is the recognizable offspring of these venerable forebears. Stretched out in a verdant landscape, the nearly naked Paul cringes and protects his eyes from the dazzling light, while his handsome, athletic horse rears up wildly behind him. A soldier—bearded and elderly, like Paul himself—points his spear at Jesus and at the angel who is flying in from the upper right hand corner. And you can't blame the old soldier for cowering. It's unclear if the heavenly visitors intend to save Paul or to harm him, and something about Christ's outstretched arm recalls the thrust with which Matthew's assassin grabs the apostle's wrist.

Except for the general impression of chaotic agitation, the composition has little in common with the final Contarelli paintings and bore few of the hallmarks that already distinguished a Caravaggio from the efforts of rival artists: the darkness, the lack of discernible background, the theatrical chiaroscuro, the contemporary setting. Perhaps that was why the priests of the Madonna della Consolazione were disappointed by a work unlikely to create the same stir as the showpieces that were currently such a source of pride for their French counterparts at San Luigi dei Francesi.

The painting was rejected, a blow to the artist's vanity and pocket-book that was presumably softened when the work was bought by Cardinal Giacomo Sannesio. During this phase of Caravaggio's career, this sequence of events—a commission destined for a public venue failed to please its sponsors and was promptly snapped up by a wealthy private citizen—would be repeated several times, and each of these incidents would take an increasing toll on the artist.

Though we hear about how unhappy he was later when *The Death of the Virgin* was refused by the Church of Santa Maria della Scala in 1602, there is no record of any friction between the short-tempered painter and any of the patrons whose rejection of his initial efforts must have caused him considerable anger and disappointment. Apparently, he was able to rein himself in when dealing with his employers and to vent his frustration in street brawls and in bad behavior in the taverns and brothels. Even as Caravaggio was working and reworking his ideas for the Cerasi Chapel, he was prosecuted (though charges were later dropped) for giving one Flavio Canonici—a former guard at the prison at the Castel Sant'-Angelo—a sword wound on the hand, not life threatening but grave enough to leave a permanent scar. Caravaggio was adept at separating the studio from the street, where the slightest insult could lead to violence. Yet when the executors of a commission required him to start over, he appears to have behaved like a consummate professional who absorbs his losses, retrenches, and begins again.

Contemplating the first and second versions of *The Conversion of Saint Paul*, we're tempted to conclude that nothing short of a revelation could have directed the leap from one to the other. We feel

that there must have been a moment of illumination not unlike Saint Paul's: a flash of insight lighting up the mystery of the difference between stasis and stillness. Instinctively, Caravaggio understood that the key was to stop struggling against the interiority, the muteness and timelessness of the event, and to take on the challenge of picturing a moment when time and motion have ceased and everything has gone silent.

In the second version, the distractions of the physical world have receded into blackness and night; the borders have closed in so tightly as to squeeze out the last breath of air. Jesus the soaring messenger has disappeared from the painting; from now on Caravaggio's Christ will be as earthbound as the viewers contemplating his image.

The figures, the two men and the horse, occupy the entire painting, and that fact alone—their size in relation to that of the whole—makes them seem monumental. Radically foreshortened, Saint Paul, younger than in the earlier version, sprawls on his cloak and sword. His arms no longer cover his face but instead are thrown open so that there is nothing between him and God, nothing between him and us. If Paul has grown younger, his horse has aged, become less skittish, thicker, more tired, more like the sorrowful donkey in *The Rest on the Flight into Egypt*. His raised hoof won't crush his thrown rider, not even if he has to hold it like that for a lifetime. The old man has decided that tending the horse is more useful and practical, less pointlessly distressing than attempting to figure out what is happening to the soldier who has fallen for no reason and is writhing, blind, on the ground.

The crowd is gone, the angels are gone, only these three creatures

remain. They could hardly be physically closer, yet each is utterly alone. Paul has already left the quotidian world that the other two still inhabit. Like *The Calling of Saint Matthew*, the painting depicts a conversion, but Paul is more like Caravaggio himself, a man for whom a more extreme and drastic awakening was required. Nothing, really, is happening here. Everything has just happened or is about to happen. Yet despite, or because of, its stillness, the scene is far more dramatic than that of Matthew being extracted from his countinghouse. Because that calling took place at an instant in time, whereas here, on the road to Damascus, Caravaggio has given us a way to imagine that what we are being shown is a moment of eternity, a frozen glimpse of forever.

If *The Conversion of Saint Paul* is at once more inward and brutal than the vocation of Saint Matthew, so the martyrdom of Peter is paradoxically less violent and more excruciating than the assassination of his brother apostle. And if Matthew's murder is as tumultuous as a random outbreak of street violence, Peter's death is as chilling and methodical as what it is: an execution. The nocturnal setting, the stillness, the simplicity of composition, the minimal cast of characters, the humble grandeur with which the figures occupy massive amounts of space, the daring decisions about which moment to portray and which figures to enlist as the main actors in the understated and nearly unbearable drama—all these elements remind us and, indeed, compel us to see that *The Martyrdom of Saint Peter* is not merely a companion piece, but the mystical counterpart of *The Conversion of Saint Paul*.

Already strapped to the instrument of his death, the apostle is

portrayed as his cross is being raised in preparation for his crucifix-ion, upside down. Again, Caravaggio's vision departs from earlier conceptions, which mostly portray the saint with his torment well under way, his body fully inverted—images in which the cruelty of his punishment has the unintended effect of distancing us from his plight. Unless we ourselves stand on our heads, we cannot see the saint's expression. And so the dying, upside-down martyr has, in effect, already ceased being human. Caravaggio's solution allows us to look directly into the suffering face of the saint, even though his eyes evade ours as he drifts toward wherever he must go in order to endure the pain that awaits him.

The key to the painting's power lies in the horrifying naturalism of the way in which Peter holds his body and his head. We feel that the saint's uncomfortable pose has been copied directly from life, that this is exactly how we would attempt to ease our misery, the precise angle at which we would lift our backs and strain our necks, had we been forced into that position, on that hard wooden plank. Perhaps Caravaggio achieved this effect by leaving his model in position long enough so that the stand-in for the saint assumed the pose that would minimize his discomfort.

The overall impression is one of overpowering loneliness, even though the apostle is involved in a sort of group activity, a species of collective labor, with the three burly workmen expending all their energy on the physically demanding task of lifting Peter's cross. Of the three, two have their backs turned to us; the third one's face is in shadow. You feel that, if you could see them, they would be expres-

sionless, utterly impassive and stolid. They take no pleasure in their work, nor do they bother with guilt or remorse. They're simply doing a job they've been hired to do, a job that needs to be done—as efficiently as possible and with the least amount of wasted effort.

As with each of Caravaggio's paintings, especially from this period, you can see him learning how to do something both marvelous and new. Here what he's discovering is the effect that can be achieved by focusing our attention on the mindless menial labor involved in martyrdom and its aftermath, a theme that will intensify the gravity and beauty of one of his late masterpieces, *The Burial of Saint Lucy*. And here, for the first time, he boldly insists on the true appearance, transcribed from life, of the callused hands and rugged backs of the laborers who carry out the killing of those whom the powerful want silenced.

Most important, he is exploring the magnitude of the compassion that he is able to make us feel for the innocent, suffering victim of a horrible crime. Everything in his portrayal of Peter—the intersecting furrows in his brow, the sharp crease traversing his stomach, the way that one of the workers embraces his shins while raising the cross without any perceptible awareness that he is touching a living human being—all of it increases our sympathy until we feel that an actual execution is transpiring in front of our eyes and that we have to turn away because we can hardly stand to see it.

By this time the double life that Caravaggio had been leading—as a member of Del Monte's exquisitely refined milieu and as a street

gangster drinking in the taverns and dueling in the back alleys of the Campo Marzio—must have begun to seem simple compared with the multiple sets of manners and mores he was now obliged to adopt as he moved among a wide range of social circles and conducted what amounted to a series of parallel, interrelated careers. Even as he was finishing his deeply felt religious masterpieces for the Contarelli and Cerasi Chapels, he was also working for hire, painting portraits of anyone who had enough celebrity to intrigue him or enough money to pay his fees.

As if to make it perfectly clear that his depictions of Saint Paul's and Saint Matthew's conversions did not signify that he himself had suddenly felt called to walk the straight and narrow path of the righteous, Caravaggio painted two of his most provocative and disquietingly homoerotic works, full-length nudes of the same dark-haired, smooth-skinned prepubescent boy. Sprawled with his buttocks pressed against a fur pelt, *Saint John the Baptist* grins saucily at us as he flings his arms around the neck of a shaggy old ram. Except for the single jarring note—that only one of them is human—the pair precisely models the discrepancies (young vs. mature, smooth vs. hirsute) that, in Caravaggio's era, were culturally required attributes of the acceptable homosexual couple. The fact that the boy's pose is modeled so closely on one of Michelangelo's nudes in the Sistine Chapel adds the extra *frisson* of an art joke, a tribute or an insult to a masterwork of the past that amplifies the painting's already considerable outrageousness.

Victorious Cupid, a sly, impudent—and winged—boy stands with

one leg folded back on a bench covered by a tangled bedsheet. His thighs are spread, his penis exposed. One of his hands is either behind, or on, his buttocks, calling attention to his perfect little rear. His look of delighted triumph seems partly inspired by the fact that the artifacts and symbols of knowledge, culture, and civilization—musical instruments, a pen and a book, military armor, scientific and mathematical implements, a crown and a globe—have effectively cast themselves at his pretty feet. It's hard to talk about these paintings without sounding as if one is squinting at the past with the myopic eyes of the present, as if we wish to defile the innocence of an earlier era with the puritanical assumptions of a society that can no longer see a child's beauty admired without diagnosing a case of pedophilia. But to paraphrase Dickens on the death of Little Nell, it would take a heart of stone not to feel that these works were intended to convey a sexual charge, that these boys' expressions and poses were consciously meant to be teasing, enticing, and seductive.

The *Cupid* was commissioned by Del Monte's friend Vincenzo Giustiniani, who hung it in the same room as his most prized old masters. Sandrart would later say that Giustiniani kept the painting (which Giustiniani refused to sell, even when he was offered an exorbitant price) hidden under a dark green silk cloth. The story that was circulated was that he covered the painting to prevent it from making all the other 120 works in the room seem pale and inferior by contrast.

In 1603, a certain Cardinal Ottavio Paravicino wrote a cautionary letter to a friend who had bought a painting of Caravaggio's. In

a famous remark, the cardinal warned his friend to be careful, because Caravaggio had a fondness for doing work that straddled the middle ground between "the sacred and the profane." In fact it went beyond a fondness and was something more closely resembling a credo. Indeed, Caravaggio insisted on his freedom to defy categorization, his right to make art according to his convictions and out of whatever engaged his intellect and his soul, as well as his creative, religious, and erotic impulses. More to the point, he believed that the sacred could often be found *in* the profane, in the broad shoulders of the gravedigger and the executioner, and perhaps even in the smooth skin and alluring smile of the preadolescent boy.

It took nerve to be known as the creator of both *The Crucifixion of Saint Peter* and *Victorious Cupid,* and inevitably that courage amplified Caravaggio's reputation—and his notoriety. His work was discussed and widely admired by many of Rome's most famous writers and literary figures, and it became a mark of status to have one's likeness painted by Caravaggio. Poets and musicians wrote lyrics and madrigals in praise of his style, which was said to possess a kind of magic that so bewitched the viewer that people became confused: Were they looking at the real world or one of Michelangelo Merisi's paintings?

Caravaggio became a close associate of the well-known poet Giambattista Marino, who also had parallel careers in art and crime. Marino had been accused both of sodomy and of impregnating an unmarried girl—yet more evidence of the fact that, at the time, these two activities would not have been considered mutually exclusive. Before leaving Naples for Rome, Marino had been jailed for forging

papers on behalf of a friend who was eventually executed. Doubtless because of the fact that Marino was not a painter—and therefore not a potential rival—he and Caravaggio appear to have had a friendship that inspired them both without the anxiety of the competition that so often soured Caravaggio's associations with his fellow artists.

Caravaggio painted Marino's portrait, and the poet responded by composing a sonnet extolling the painting's virtues. Marino wrote laments for Narcissus, the Greek youth who was so harshly punished for his excessive self-regard, and Caravaggio painted his sensitive study of Narcissus gazing at his reflection in the water.

Unlike Caravaggio's Cupid and his Saint John the Baptist, his Narcissus has no interest in us, or in anything but his own image. Likewise, the painter's attention seems focused less on the work's potential effect on the viewer than on the formal—the geometric—aspects of its composition. As Narcissus kneels at the edge of the pool with his head turned to one side, his body describes a sort of arch, the two columns of his arms traversed by the horizontal of his shoulders. That shape is repeated in his reflection, so that the mirror image and the reality join in an oval, its two halves linked at the points at which Narcissus appears to be holding hands with himself and thus forming his own one-man, off-center circle.

At some point between November 1600 and June of the following year, Caravaggio, for reasons that have never been explained, left Del Monte's residence at the Palazzo Madama and moved into the palace of Del Monte's friend Cardinal Girolamo Mattei, a member of an extremely wealthy and prominent Roman family. The cardinal's

brothers, Ciriaco and Asdrubale Mattei, both avid collectors of art, lived in the palace next door.

Ciriaco Mattei was already, or would soon become, one of Caravaggio's most supportive and eager patrons, acquiring his work for (by current standards) astronomical prices, sums equaling those the artist received for several of his church commissions and that were far beyond the relatively modest means of Del Monte. Baglione suggests that Ciriaco was duped by all the publicity and gossip surrounding Caravaggio; he adds that the artist relieved the gentleman of many hundreds of *scudi*. Duped or not, Ciriaco bought *Saint John the Baptist* as a gift for his son, again raising the question of whether the suggestive male nude would really have seemed as lubricious to Caravaggio's contemporaries as it appears to us, which would have made it an odd present for a respected aristocrat to give his son.

Ciriaco Mattei also purchased *The Supper at Emmaus*, a depiction of Luke's account of the incident that occurred on the road to Emmaus, when Christ fell in with two disciples who had previously refused to believe reports that he had risen from the dead. Not until they shared a humble meal, and Christ broke bread and gave it to them, did they understand who it was that walked among them— and at that very instant Jesus disappeared.

Typically, Caravaggio cuts straight to the dramatic climax, to the moment when realization is nearly rocketing the two pilgrims out of their seats. The old man on the right has thrown his arms open in the gesture that, in Caravaggio's work, signals not only shock but the helpless and reflexive baring of the heart. And the pilgrim on the left

grips the arms of his chair as if to prevent himself from levitating through the top of the painting. The innkeeper still hasn't figured it out. Although he is in the presence of the resurrected Lord, he has not yet removed his hat.

The use of light and shadow, and of perspective—the way the table recedes into space even as the elderly pilgrim's hand leaps out of it—is masterful. Young, plump, beardless, his radiance undimmed by the agony he has just endured, Jesus gazes downward with a beneficent but unreadable expression. On the table is a basket of damaged fruit that recalls Caravaggio's earlier still life. Bellori complained that the figs and pomegranates were out of season for the meal that would have taken place in the spring.

It's the bright, redemptive aftermath of *The Taking of Christ*, which Caravaggio also did for the Mattei family, and which is believed to have hung in the palace together with *The Supper at Emmaus*. In many ways evocative of *The Martyrdom of Saint Matthew*, it, too, offers a searing vision of chaos and grief that focuses on the perversely intimate bond between the betrayed and his betrayer. It's another turbulent crowd scene, but here there is no architecture, no background; the figures filling the picture space could hardly be jammed in more tightly. Wearing a visored helmet and dark armor, the soldier seizing Jesus commands the center of the painting. Reaching across Judas to get at Jesus, whom Judas is embracing, the soldier seems to be grabbing them both at once, or else sandwiching Judas between himself and Jesus.

Inscribed on Christ's and Judas's pained faces is the perfect com-

prehension of everything that this kiss will mean for themselves, and for mankind. At the far left, fleeing in terror, is an older version of the boy who ran from Matthew's murder, and on the right, Caravaggio himself makes another appearance as a witness, though now without the distress he showed over Matthew's killing. This time his face is lit by the glow of sheer curiosity, as well as by the lamp he holds, illuminating the scene. He's just trying to see what's going on. And really, why should it matter if the light from his lamp enables the soldiers to find their man, the one whom Judas is kissing? The artist is showing us what God ordained; there is no way he could have changed that.

These works, along with a third religious painting Caravaggio did during this period—a remarkably clinical and graphic *Doubting Thomas* in which the skeptical apostle is shown accepting Christ's invitation to probe, with his finger, the wound in Jesus's side—must have been satisfying for their creator. By deploying his technical virtuosity and his amazing gift for rendering the psychology of a spiritual drama, he had been able to please his audience without compromising his vision.

This was highly unlike his experience with the Contarelli and Cerasi Chapels. The pressures and complications surrounding his public commissions had been, and would continue to be, very different from the circumstances under which he worked for the appreciative private patrons who competed among themselves to acquire his latest efforts.

In the winter of 1602, Caravaggio signed a contract to paint Saint

Matthew being inspired by an angel. The painting was to hang in the space between the two that he had already done for the Contarelli Chapel, in the Church of San Luigi dei Francesi.

In the first version Caravaggio submitted, Matthew—elderly, stocky, barefoot, bearded, nearly bald—sits cross-legged in a chair, holding an open book in his lap. His forehead wrinkles with strain as he peers at the Hebrew letters. A winged, androgynous, diaphanously clad angel leans over his shoulder, gently resting his slim fingertips on the back of Matthew's rough meat hook of a hand.

The painting was summarily rejected by the Fathers of San Luigi, evidently because Matthew looked more like a laborer who might have built the church than any accepted or acceptable portrait of the apostle who helped found it. By contrast, the adjacent images of the saint as the startled tax collector and the murdered (or about to be murdered) priest look aristocratic and patrician. According to Bellori, the painting was taken down because the priests claimed that the figure, with his crossed legs and his feet rudely exposed to the public, had neither the appearance nor the decorum of a saint.

Only the bare feet, the beard, and the baldness carry over into the second, approved version. Now the haloed saint wears a flowing orange robe, beneath which is the tall, attenuated body—and the feet—of a man who seems more accustomed to intellectual activity than to physical labor. And the angel, who has backed off and ascended to the top of the painting, no longer seems to be teaching Matthew how to read.

Describing Caravaggio's response to the French priests' lack of

enthusiasm for the first Saint Matthew, Bellori twice uses the word *despair* and adds that the painter was extremely disturbed by the effect the rejection might have on his reputation and by this affront to his public work. As with the first version of *The Conversion of Saint Paul*, the day—and Caravaggio's pride—was saved when the rejected work was acquired by a private collector, in this case Vincenzo Giustiniani.

By now, the ecclesiastical authorities responsible for planning the decoration of the great churches of Rome would have had plenty of opportunity to form a reasonably accurate idea of the potential advantages and possible dangers of choosing Michelangelo Merisi. Doubtless they would have heard about other priests' experiences and observed the results. And they would have been able to decide for themselves if the benefits of hiring a painter whose brilliant originality might increase both the exaltation of the faithful and the fame of their congregation would outweigh the problems that might ensue if his work turned out to be *too* original, *too* inconveniently daring.

The Oratorian Fathers of the Church of Santa Maria in Vallicella, the so-called Chiesa Nuova, or "new church," were willing to take the risk, perhaps because their order was so strongly committed to the virtues of humility, simplicity, and naturalness, the spiritual principles that Caravaggio had turned into an aesthetic. Sometime in 1601 or 1602, Caravaggio was asked to paint *The Entombment of Christ* for Santa Maria in Vallicella's Chapel of the Pietà, thus forming a sort of narrative bridge between two adjacent chapels, one commemorating the Crucifixion, the other celebrating the Ascension.

Until now the majority of Caravaggio's religious paintings had fixed on the terror of revelation, on surprise and shock, brutality and violence, suffering and endurance. But the mood of *The Entombment of Christ* is one of tenderness and compassion, and the moment we see is transpiring after the agony of the body has ended and the mourners' grief is about to be relieved by a glimmer of the light that awaits on the far side of sorrow and pain.

The painting is still sometimes referred to as *The Deposition of Christ*, as both Bellori and Mancini call it. But in fact it's not the traditional image of the awkward, dolorous labor of lifting the lifeless Savior down from the cross. One can imagine that Caravaggio, with his passionate interest in the physical effort required for a miracle to occur, might have been tempted to picture that scene. But perhaps inspired by the sympathies of the Oratorian Fathers, he so thoroughly resisted this impulse that the cross—the instrument of cruelty, torture, and death—does not even appear in this redemptive and compassionate painting.

Five ordinary, humble people, three women and two men, have gathered to carry, and lament over, the body of Christ. The barefoot, burly Nicodemus, his face strikingly similar to Michelangelo Buonarroti's, gazes out of the painting. But sadness has turned him inward, and he doesn't engage with the viewer as he bends to hold Jesus's knees. He's the kindhearted equivalent of the laborer in *The Crucifixion of Saint Peter*, the one who impassively holds the saint's shins while the cross is being raised. Weightless enough so that Saint John needs only one arm beneath his back, Christ can no longer be

hurt, not even when his disciple's fingertips accidentally press his wound. We are the ones who feel the pain of his terrible vulnerability.

Christ's mouth is open, his head is tipped back, his arm hangs plumb and grazes the stone. Only the careful imitation of nature—made possible by staging a tableau in which the live model held his uncomfortable pose until his body assumed the precise curve of the dead Jesus—could have made the reality of recent, undeserved death so palpable and so convincing. Confronted by the sadness of the scene, we take our cue from the middle-aged Madonna, who extends her arms in a blessing that conveys forbearance and forgiveness, and also from the young woman, who raises her hands and catches the light like Saul on the road to Damascus.

How could the Oratorian fathers not have admired and valued this affecting depiction of human loving-kindness, and of the instant when despair turns phototropically toward hope? The altarpiece was such a huge success that even Baglione felt obliged to report that it was said to be Caravaggio's finest. Many artists would copy it, including Paul Cézanne, who painted it in watercolor without having seen the original. The acclaim, and the ease with which it came, should have set the tone for this innovative and inspired period in Caravaggio's career.

But, sadly, he would soon begin to undergo a series of bruising experiences that more closely resembled the difficult time he'd had in his work on the Contarelli Chapel. That cautionary, troubling glimpse of the gap between Caravaggio and his ecclesiastical patrons, of how far they lagged behind him and of how reluctant they

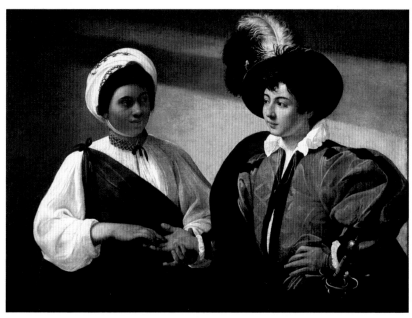

The Gypsy Fortune–teller (Louvre/Paris)

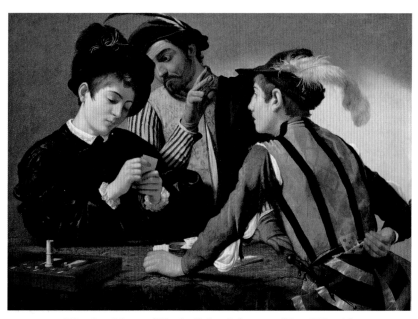

The Cardsharps (Kimbell Art Museum/Fort Worth)

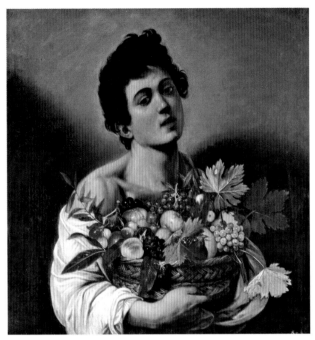

Boy with a Basket of Fruit (Galleria Borghese/Rome)

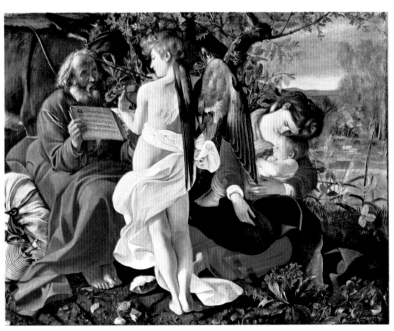

The Rest on the Flight into Egypt (Galleria Doria-Pamphilj/Rome)

The Death of the Virgin (Louvre/Paris)

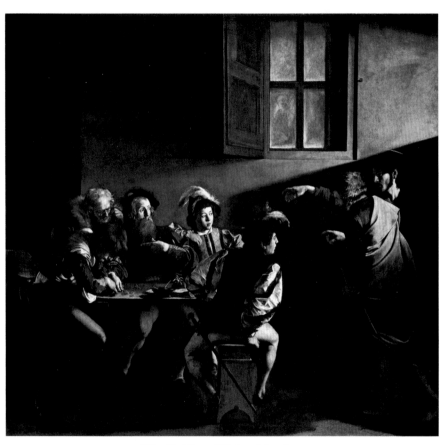

The Calling of Saint Matthew
(Contarelli Chapel, San Luigi dei Francesi/Rome)

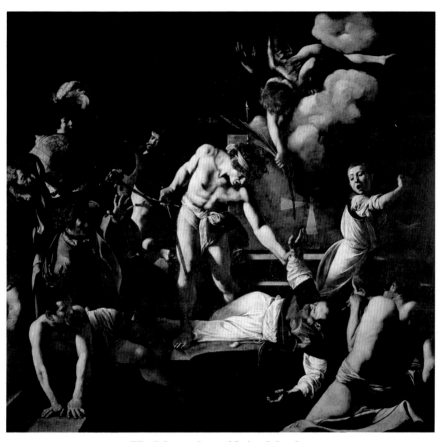

The Martyrdom of Saint Matthew
(Contarelli Chapel, San Luigi dei Francesi/Rome)

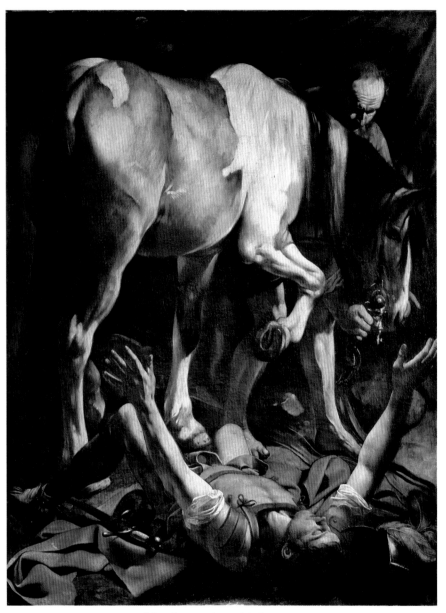

The Conversion of Saint Paul
(Cerasi Chapel, Santa Maria del Popolo/Rome)

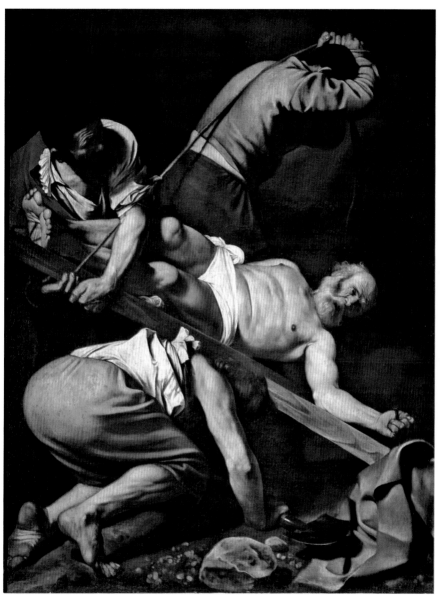

The Crucifixion of Saint Peter
(Cerasi Chapel, Santa Maria del Popolo/Rome)

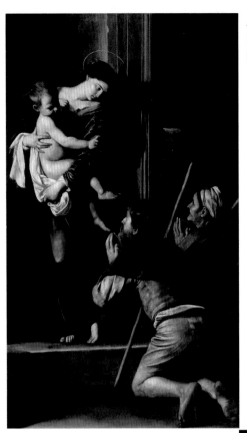

Madonna of Loreto
(Cavalletti Chapel,
San Agostino/Rome)

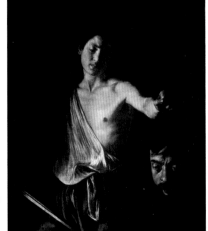

David with the Head of Goliath
(Galleria Borghese/Rome)

were to keep up with the leaps of his visionary genius, would prove to be a portent of the near and distant future.

To contemplate the work of Giovanni Baglione alongside that of Caravaggio restores our faith in those hopeful clichés that promise that posterity will prove wiser and clearer-sighted than the myopic present. Time will separate the wheat from the chaff. Cream will rise to the top even if it takes centuries to complete its erratic and uncertain percolation.

From this distance, it's astonishing to contemplate the notion that the two painters were considered, and considered each other, to be serious rivals. By now, at least, common sense has prevailed, since Caravaggio is everywhere acknowledged as a genius, while Baglione has become—to quote the press release for a recent scholarly volume bravely attempting to salvage the painter's reputation—"one of the most reviled artists who ever lived."

Meanwhile, it's sobering, instructive, and useful to realize how many of their contemporaries failed to notice that Baglione's work, especially during one particular interval in his career, was not merely an imitation of Caravaggio's style but a parody that simplified what was most complex, stiffened what was most fluid, and trivialized what was most profound about the great painter's vision. Though the original is in a private collection, it's worth tracking down a reproduction of Baglione's *Saint Sebastian Healed by an Angel*—a treacly and bizarre depiction of an angel extracting an arrow from the swooning saint's creamy side—to see how very wrong things could

go when the themes and techniques that would become known as "Caravaggism" were employed by a lesser talent. The intimation of an eroticized, sadomasochistic charge between the prepubescent martyr and the even younger boy playing the heavenly messenger is only the most blatant of the painting's creepy, disquieting elements.

The posthumous correction of the two artists' relative standing occurred despite the fact that Baglione did everything in his power to have the last word. His biography of Caravaggio—which was probably written around 1625 and which appeared in 1642—provides the most detailed firsthand account of his rival, a portrait characterized by a tone that is not only dismissive and censorious ("Some people thought he had destroyed the art of painting") but deeply unsympathetic ("He died as miserably as he lived").

During the 1580s, Baglione was commissioned by Pope Sixtus V and then by Clement VIII to take part in the decoration of the Vatican and the Cathedral of Saint John Lateran. Later, he was hired by Cardinal Nicolò Sfondrato to work on Rome's beautiful Church of Santa Cecilia. Deeply impressed by Caravaggio's originality, he became the first of Caravaggio's numerous imitators. His *Divine Love Overcoming the World, the Flesh, and the Devil* was a direct response to, and an attempt to outdo, Caravaggio's *Victorious Cupid*.

In Baglione's effort, a decidedly over-the-top silliness dulls the faintly pornographic, homoerotic, and sadomasochistic sheen of the scene in which a muscular youth costumed as a winged angel, with long ringlets and armor resembling metal underwear, rudely interrupts whatever has been going on between the devil and the naked-

boy Cupid, who delicately recoils from the physical punishment that Divine Love threatens. After dedicating the painting to Cardinal Benedetto Giustiniani, the brother of Vincenzo, who was Caravaggio's loyal collector, Baglione redid the work to accommodate the criticisms of fellow artists, who suggested that the figure of Divine Love should be younger, and naked. In the second attempt, the angel bares one shapely leg, and the devil twists around to leer at the viewer with a grotesque face that, some have suggested, resembles Caravaggio's.

Oblivious to the painting's obvious flaws, Giustiniani rewarded Baglione with a gold chain, at the time an important public symbol of accomplishment and success that the most celebrated painters desired and proudly displayed in their own self-portraits. The very idea of Baglione's gold chain must have been like a dagger in Caravaggio's heart, and his sense of outrage and injustice spiked when in 1602 Baglione received the important and widely coveted commission to paint the altarpiece for the Church of the Gesù. It may be that the Jesuits, who would have heard about the difficulties associated with Caravaggio's work on the Cerasi and Contarelli Chapels, felt safer hiring the more conventional and predictable Baglione.

Baglione darkened his ambitious, overly busy, and unfocused vision of the *Resurrection* with some Caravaggesque touches—specifically, a group of hunky soldiers lounging in the recesses of the shadowy crypt. First exhibited on Easter Sunday in 1603, the altarpiece was reviled by Baglione's peers, whose irrritation might have been tempered had they known how soon the painting would disappear

from history. Its replacement, by Carlo Maratta, was installed at the end of the seventeenth century, and only a preliminary drawing survives to illustrate Baglione's design. Yet Baglione appears to have been one of those artists with a gift for failing upward. He worked on Saint Peter's and Santa Maria Maggiore; he was knighted and appointed president of the artist's association, the Accademia di San Luca.

After the unveiling of the Gesù altarpiece, the tensions between Baglione and Caravaggio—both supported by rival camps of followers—worsened. In his biography of Caravaggio, Baglione tells us how the arrogant Michelangelo Merisi, convinced of his own unique brilliance, often spoke ill of his predecessors and his contemporaries.

Interestingly, however, Baglione neglects to mention the fact that he himself was so upset by one of these insults that, in August 1603, he lodged a complaint with the governor of Rome, alleging that Michelangelo Merisi, Orazio Gentileschi, and Onorio Longhi had been slandering him and defaming his art ever since his depiction of the Resurrection had been unveiled. The reason, he suggested, was that they were jealous because his work was more highly respected than theirs, and because they—or actually, only Michelangelo Merisi—had wanted the prestigious commission from the Jesuits. Specifically, claimed Baglione, the three rival painters had written a series of scurrilous poems about him. He requested that his tormentors and their accomplices be brought to justice and prosecuted to the full extent of the law.

The scandal, the poems, and the testimony at the hearings open a window through which we can glimpse the gladiatorial combat

that passed for daily life in the Roman art world: the competition, the gossip, the nervous monitoring of every minuscule decline and uptick in a rival's reputation, and the very real threats lurking beneath the deceptively collegial surface. Anxiety, contempt, rage, and an aggrieved sense of injustice are the not-so-hidden subtext of the scatological and obscene poems directed at Baglione.

The verses predict that Baglione's utter lack of talent would soon reduce him to the point at which he could no longer afford the cloth for breeches to cover his naked behind. They suggest that he bring his drawings to the grocer, or use them for toilet paper, or give them to the wife of Baglione's friend Tommaso Salini (a hugely unpopular and notoriously nasty painter), who could put them in her vagina so as to prevent Salini from having sex with her. The poems refer repeatedly to the sore subject of the gold chain: Baglione is undeserving and unfit to wear it; an iron chain around his ankles would be more appropriate.

In his testimony, Salini claimed that the painter Filippo Trisegni gave him the poems when he asked Trisegni what the artists in Rome were saying about Baglione's altarpiece for the Church of the Gesù. The poems, Trisegni was supposed to have said, were written by Caravaggio, Gentileschi, and Longhi, and another painter, Ottavio Leoni. Concerned about the consequences of a possible scandal, Caravaggio, claimed Trisegni, had warned him not to let Baglione and Salini see the poems. But the temptation to show the verses to the men they defamed had proved irresistible. According to Salini, Trisegni reported that he'd gotten Caravaggio's poem from the

bardassa, a boy named Giovanni Battista, whose affections Caravaggio shared with Onorio Longhi. *Bardassa* was a pejorative term for a young male prostitute, a promiscuous professional who had sex for money, as opposed to an ordinary adolescent who, for reasons of the heart rather than the purse, became the lover of an older man. Later, Trisegni would deny the detail of the *bardassa*, and Salini remains the only source of this incriminating allegation.

In September, Caravaggio was arrested in the Piazza Navona and imprisoned on the libel charge, as were Gentileschi and Trisegni. The police failed to catch up with Longhi but nonetheless seized papers and evidence from his lodgings.

In his testimony, Trisegni admitted that he'd shown the poems to Salini, but denied revealing who had written them. Instead, he said, he had teased Salini, dropping hints, inviting him to guess, and rather touchingly agreeing to tell him the truth only if Salini showed him how to paint the way a figure cast a shadow. But Salini refused to give Trisegni the lesson he had requested, and so Trisegni kept the poets' identities secret. Trisegni added that Gregorio Rotolanti, another painter, had informed him that one of the poems had been written by a young student of logic and medicine.

Orazio Gentileschi testified about the handwriting on some documents found in his home. And the next day, Trisegni and Salini were reexamined, in an unsuccessful attempt to resolve the discrepancies between their conflicting versions of events. The two men stuck to their stories, and Salini insisted with particular vehemence on the embarrassing and potentially damaging detail of Caravaggio's officially illegal *bardassa*.

Caravaggio took the stand on September 13, 1603. To read his deposition is an almost eerie experience. It is the only time we hear him speak directly, and at some length, and yet our encounter with him is ultimately as elusive and frustrating as it must have been for the magistrates who examined him. It could hardly have been his finest hour; he had been imprisoned and was being required to defend himself in what we would now call a nuisance suit brought by a man whose work he considered beneath contempt.

His testimony is digressive, contradictory, and only marginally relevant to the central question of whether or not he helped write the verses defaming Baglione. On trial, with his freedom at stake, he cannot resist the chance to discuss, in a public forum, his convictions about painting. All he really wants to talk about is art: who are the artists in Rome, who are the good artists, what constitutes a good artist, what good art is. The question of whether or not he libeled Baglione seems to him inconsequential compared with the fact that Baglione is a terrible painter and that everyone knows it.

Caravaggio begins by saying that he has no idea why he was arrested in the Piazza Navona. He identifies himself as a painter, claims to know almost all the painters in Rome, and goes on to list eleven of them by name. Nearly all of them are his friends, he says, though he soon amends this by adding that several, including Cesari, Baglione, Gentileschi, and a certain "George the German," aren't speaking to him. In their testimony, both Caravaggio and Gentileschi go to some lengths to establish that they have not been in contact with each other and thus could not have co-authored the poems about Baglione. According to Gentileschi, their estrangement

has lasted six to eight months, while Caravaggio says that they have not exchanged a word—oddly, for two close friends in Rome's small artistic community—for three years.

In any case, Caravaggio continues, not all the painters he has listed are good artists. Asked to define a good artist, he replies, a bit redundantly, that he means an artist who knows how to paint well and who has an understanding of painting. More important—and Caravaggio is making a particular point here, staking out territory, advocating the realism in which he believed so strongly—a good painter is one who knows how to imitate nature. Among the good painters, he says, are d'Arpino, Zuccaro, Il Pomarancio, and Annibale Carracci—a puzzling statement, considering that he was known to despise d'Arpino, and had no reason to admire the conventional Zuccaro, who had made the infamous remark about Caravaggio having accomplished nothing that Giorgione hadn't already done better. Perhaps Caravaggio was mocking the question, or perhaps the truth was that he considered none of them (with the exception of Annibale Carracci) to be good painters, and was merely choosing a few names at random to underline the pointlessness of this whole line of inquiry.

On the subject of Baglione, Caravaggio is comparatively terse. No one except Baglione's friend Salini has ever had a good word to say about Baglione's work, which Caravaggio has seen, nearly in its entirety. The new altarpiece in the Gesù is not only clumsy but the worst thing Baglione has ever done. In fact, no one but Salini has ever praised the painting. As for the libel charge, Caravaggio has

never discussed Baglione's painting with his friend Onorio Longhi. He hasn't talked to Gentileschi for three years and has never spoken to Ottavio Leoni. Finally, he has never heard of the verses about Baglione, nor does he take any pleasure in writing poetry in Italian or Latin. And he has no knowledge at all of the so-called *bardassa*.

Returning for a second round of questioning, Gentileschi tells the story of how Baglione got his gold chain as a reward for his *Divine Love*, of his futile attempt to compete with Caravaggio, and of how Baglione repainted *Divine Love* after Gentileschi criticized it. After that, says Gentileschi, he and Baglione stopped speaking. Moreover Gentileschi claims not to have talked to Caravaggio for six or eight months, though during that time Caravaggio borrowed two studio props from him—a Capuchin's robe and a pair of angel wings, which he returned around ten days before the trial. The loan of the props is exactly the sort of unnecessary detail that the unsuccessful liar can't help adding, though it may also represent Gentileschi's efforts to cover himself in case someone produced the messenger or servant who actually brought back the wings.

And that was that. The trial ended. Two weeks later, Caravaggio was released from the Tor di Nona prison with the proviso that he remain under house arrest and reappear before the court at some point during the following month.

But matters were far from settled between the two rival art gangs, the friends of Caravaggio and the less numerous supporters of Baglione. Returning to Rome, from which he had prudently absented himself during the trial, Longhi registered his opinion of the

proceedings by assaulting Baglione with a brick, and was promptly jailed. Caravaggio left Rome, most likely for Tolentino, where he is thought to have painted an altarpiece—now lost—for the Capuchin Church of Santa Maria di Constantinopoli. Caravaggio's trip to the Marches was the first in a series of hasty retreats from the capital, departures designed to let the latest scandal or feud cool down. But inevitably, on his return, he would plunge back into a climate that had only grown stormier and more inhospitable during his absence.

On April 24, 1604, a waiter at the Osteria del Moro, near the Church of the Magdalene, filed a formal complaint against Michelangelo da Caravaggio, a painter. According to the waiter, Caravaggio—who was eating lunch at the tavern with two friends—had ordered eight artichokes, four fried in oil, and four fried in butter. When Caravaggio asked which ones had been prepared with oil, and which with butter, the waiter suggested that he could tell quite easily by smelling them. (An eyewitness remembered the event somewhat differently, recalling that the waiter himself had picked up one of the artichokes and held it to his nose.) Caravaggio responded by throwing the earthenware plate of artichokes in the waiter's face and grabbing for his friend's sword. Convinced that he was about to be attacked, the waiter fled—straight to the magistrate's office.

Eventually the charges against Caravaggio were dropped. But in October, he was again arraigned, this time for throwing stones at the police. Caravaggio denied having committed the offense. He added

that when he advised the constables to go look for the man who had actually thrown the stones, he never used anything like the vulgar language that he was charged with having employed. In November, he was arrested again and imprisoned in the Tor di Nona for cursing a policeman (the same man with whom he had been in trouble before, and with whom he was evidently feuding) after the constable asked to see his license to carry a weapon, a document that, on this occasion, Caravaggio was able to produce.

On May 28 of the following year, in the early hours of the morning, Caravaggio was seized on the Corso, in front of the Church of Sant'Ambrogio, and arrested for carrying a sword and a dagger. In his testimony, Caravaggio claimed that the governor of Rome had given him permission to bear arms. He was set free and given three days to prepare his defense. Again the charges were dropped.

Caravaggio was becoming more volatile and irascible, even as the police were obviously seizing every opportunity to harass and confront him in situations that would only lead to more arguments and insults, more arrests and imprisonments. Doubtless the constables were frustrated by their inability to make their charges against him stick—that is, to override the influence of the painter's powerful supporters, like Del Monte, who could be counted on to intercede on his behalf.

The police and court reports conjure up the sort of dangerous game we've seen in all those B movies in which the cops are as obsessively determined to bring a bad kid to justice as the kid is hellbent on eluding and defying the law. But among the details that

distinguish Michelangelo Merisi's case from that clichéd scenario are, first, the fact of his celebrity and genius, and second, the fact that he was hardly a kid. In 1605, the year in which his numerous arraignments may well represent a mere fraction of the incidents in which he was involved, Michelangelo Merisi da Caravaggio was thirty-four years old, and he appeared to be growing steadily more aggressive, impulsive, and hostile with age.

On July 20, two months after his arrest near the Church of Sant'-Ambrogio, a group of his friends managed to get him released from the Tor di Nona prison on the promise that he would appear in court to face the charges brought by a woman named Laura and her daughter Isabella, both of whom he had allegedly insulted.

Nine days later, a clerk of the court recorded a deposition from a notary named Mariano da Pasqualone, who testified that, the previous evening, he had been walking in the Piazza Navona when he was attacked from behind and wounded by a sword blow to the back of his head. He was sure that his assailant was Michelangelo da Caravaggio, the painter, the only person with whom had had a dispute that might have provoked the assualt. The original altercation had taken place on the Corso over a woman named Lena. She was Caravaggio's woman, according to Pasqualone, who then asked the clerk if he could be excused immediately so that he could dress his wounds. The clerk then deposed the notary's friend, Galeazzo Roccasecca, who said that Pasqualone had been struck by a sword or hunting knife wielded by a man with a black cloak on one shoulder, who then turned and headed for the palace of Cardinal Del Monte.

Evidently realizing that the evidence against him was damaging, Caravaggio left for Genoa. Returning a month later, he extended a formal apology to Pasqualone. In the official document, he swore that he was sorry for the assault and begged for the notary's forgiveness. This act of atonement, verging on self-abasement, was apparently sufficient to enable him to receive a pardon from the governor of Rome.

But his troubles, and his public contrition, did little to arouse the sympathies of his landlady, whom he had not paid any rent for the past six months. On the same day that his peace accord with Pasqualone was brokered, Caravaggio was evicted from his lodgings in the Campo Marzio. All his possessions were seized and inventoried. Once more, Caravaggio responded counterproductively, by throwing stones at his former landlady's window, breaking her Venetian blinds and, together with some friends, purposely causing a disturbance in the street outside her house. On September 1, 1605, the woman, Prudenzia Bruna, filed a complaint, in which she mentioned the painter's failure to pay his rent and the damage he had done to her ceiling.

If Carravagio's outbursts and flare-ups were alarming, his subsequent silence in the face of insult and injury seems somehow even more frightening. On October 24, he was questioned by a court notary regarding an injury to his ear and his throat, wounds that, his interviewer reported, were completely covered by bandages. Caravaggio, who was now homeless and staying with a friend, a lawyer named Andrea Ruffetti, claimed that he had fallen down the stairs—

unobserved, and in some unknown and forgotten location—and that he had hurt himself with his own sword. Otherwise, he had no idea how the accident had occurred, and neither had anyone else.

For all we know, the propensity for violence that Caravaggio displayed all through this period might have been equally extreme if his career had been proceeding smoothly. Perhaps he would have been just as aggressive had he not been obliged to deal with a series of professional setbacks that would inevitably have created some anxiety about his ability to maintain his standing at the top of the perpetually shifting hierarchy of artists then working in Rome.

Still, it's tempting to suppose that at least some of those brawls, vendettas, and flashes of temper had some connection to the imbroglios and frustrations that had begun to surround so many of his religious commissions. Mancini connected Caravaggio's "torment" with the inhospitable reception that *The Death of the Virgin* had received from the church that had commissioned it. And how could the painter's rage and sorrow not have been intensified by the painful awareness—which surely he must have had—that the disputed and rejected works included some of his greatest masterpieces?

The problem with *The Death of the Virgin*, wrote Bellori, was that the dead Madonna looked too much like the bloated corpse of a real woman, and Baglione agreed about the indecorousness of showing the Virgin swollen and bare legged. Mancini, who would later try to buy the canvas when it came on the market, went a step further, combining an analysis of the painting's subject with some additional

thoughts on the damage it did to Caravaggio and to the artists who came after him. As an example of how badly some modern artists painted, Mancini cited those who, "when they want to portray the Virgin Our Lady, show some dirty whore from the Ortaccio"—that is, the prostitute's quarter near the Mausoleum of Augustus—"which is what Caravaggio did in *The Death of the Virgin* for the Madonna della Scala, which is why the good fathers didn't want it, and perhaps why the poor fellow [Caravaggio] suffered such torment in his life."

"Some dirty whore from the Ortaccio." The sweetness and grace of the beautiful young Madonna would alone be enough to make us want to weep for her, and for ourselves, and for everything that is mortal, even if the apostles and the women who surround the bier on which she lies were not themselves so overcome by grief that our compassion is also aroused by our empathy for the living. The Virgin's spirit seems to have abandoned the fragile and delicate shell of her body, barefoot and clothed in a simple red gown, so recently that she is still lit from within. Something about the way in which death has arranged the Virgin's pose—one hand resting lightly on her breast, the other flung to one side—vaguely recalls the dead Christ in *The Entombment of Christ*, but, although both paintings portray the aftermath of a death, that is the only detail they have in common. If Nicodemus, Saint John, the Virgin, Mary Magdalene, and Mary Cleophas came together to share the work of easing Christ into his grave, each of the Virgin's mourners is isolated in misery, cut off from the others by a private grief. Crowded around her deathbed, they could not possibly be more alone.

The same Magdalene who stood radiant and in tears over the dead Christ can no longer remain upright. Collapsed in a chair, sunk into herself, she hides her face, wiping her eyes with her sleeve, just as someone might when she no longer knows or cares if anyone is watching. Two of the apostles cover their eyes; their brothers regard the Virgin. But the light that shines on her does not and cannot reach them. A copper pan lies at the foot of the bed; otherwise the room is bare. Above the figures is a red curtain, a crude wooden ceiling, beams—a dark, empty, and frightening space. We notice, as we are meant to, the absence of heavenly light or of any suggestion of heaven, the lack of anything that might offer the slightest hint or promise of the cessation of sorrow and pain, let alone of redemption. Grief has never been rendered more accurately, or more movingly, or more faithfully to that moment when grief persuades us that there is nothing and never will be anything in the world but all-consuming and unending grief.

Perhaps it was the nakedness of that grief, rather than the bareness of the Virgin's feet, that so alarmed and upset the "good fathers" that they felt they had no choice but to reject the painting. Or more likely it was the way in which the painting focused on the death of the body rather than the Virgin's assumption into heaven, the ascension that guaranteed that she would remain as spotless and pure in death, as free from stain and corruption, as she was in life. For how could the priests preach the life eternal, the consolations of paradise everlasting, in front of a canvas depicting the dark tunnel of loss, grief, and death without a glimmer of light at its end? Once more Caravaggio's work had taken a giant leap toward something more

tragic, resonant, and universal, more emotionally overwhelming than anything he had done before. And once more the world had made it clear to him that he had captured something so real that no one wanted to see it.

It was not until the spring of 1607 that the rejected painting found a buyer. A passionate admirer of Caravaggio's, Peter Paul Rubens persuaded the duke of Mantua to purchase *The Death of the Virgin*, which was sent off to Mantua after being on display in Rome for a week so local painters could see it. But by then, the happy news could hardly have provided much comfort to Caravaggio, who had fled Rome (for good, as it would turn out) and briefly found refuge and work in Naples.

The Death of the Virgin expressed the essence of everything Caravaggio believed about art. The simultaneously theatrical and naturalistic casting of ordinary human beings in intensely affecting religious dramas and the translation of biblical narrative from storybook fantasy into contemporary reality have an emotional immediacy and an impact on the viewer that the idealized, saccharine, and spiritually "uplifting" work of his contemporaries could never come close to attaining. And when the painting was rejected, it must have crossed his mind that those ideas—which were always, at best, warily regarded, dimly understood, and only tentatively embraced by many of the ecclesiastical officials who hired him to decorate their altars— were also in danger of being rejected by the priests, the patrons, and the art world of Rome.

The news of that rejection must have been a relief to those whose

essentially conservative tastes were offended by the principles and the power of Caravaggio's work. And how it must have reassured them to find out that they had been right all along in preferring Cesari's neatly coiffed, brightly robed, squeaky-clean saints to Caravaggio's barefoot laborers and dirty whores masquerading as dignified apostles and virginal Madonnas. Meanwhile, the wealthy and pious Romans were turning their attention to a rising talent, Guido Reni, a painter who offered the *frisson* of Caravaggism but with the rough and disturbing edges neatly sanded off. In his art, Reni promised to explore the middle ground between the dark crypts and bleak rooms in which Caravaggio's dramas took place and the cottony firmaments, teeming with pudgy cherubs, in which Baglione and d'Arpino set their Resurrections and Ascensions.

Some of this may partly explain the fervor with which Guido Reni was welcomed as the new darling of the Roman art scene. Fastidious, well-mannered, presentable, a pious and sensitive soul whose only vice was gambling and who was so devoted to the Virgin that he himself was rumored to practice a celibacy that aspired to her spotless purity, Reni was Caravaggio's opposite, and the differences in their natures were reflected in their compositions. The chasm between them remained wide even when Reni painted by the light of Caravaggio's theories—a notion that Caravaggio found infuriating. For little is more demoralizing or conducive to self-doubt than the way in which a poor imitation can point up the flaws and banalities of the original, and confirm even the most confident artist's own worst fears about his work. Like their creator, Reni's paintings are

stylish, sweet, sentimental, easy on the eye. Even in his Cara-
vaggesque phase, his imagery suggests Caravaggio's less than that of
the French romantic painters like Adolphe Bouguereau who, cen-
turies later, would recast Guido Reni's angels and pentitent Mag-
dalenes as the nymphs and bathing beauties whose heavily idealized,
perfectly pulchritudinous, and oddly sexless femininity ensured them
an elevated place in the pantheon of artists most admired and ap-
proved by the Nazi leaders.

Like Baglione, Reni was recognized by his contemporaries, in-
cluding Caravaggio himself, as a competitor and a threat. Malvasia,
an early biographer of Reni's, writes that Caravaggio asked why, if
Reni was so great, he was always trying to see and to buy Caravag-
gio's paintings. Why, Caravaggio demanded to know, had Reni
copied his technique when Reni painted *The Crucifixion of Saint
Peter* for the Church of the Tre Fontane—a commission that would
have gone to Caravaggio if d'Arpino had not unfairly interceded to
help Reni get the assignment?

Caravaggio was receiving fewer and fewer commissions, while
Reni's stock was rapidly rising. And when Pope Clement VIII died
in the winter of 1605, his successor, Paul V, promptly reverted to a
more traditional taste for the sort of heroic, exalted art that, he felt,
would reflect the importance and the ideals of his papacy. Once more
the Cavaliere d'Arpino—Guido Reni's champion—resumed his
former position as a papal favorite.

It's easy to imagine how it must have galled Caravaggio to see his
inferiors lionized and praised and to observe the ebbing enthusiasm

for his own work and ideas. Marked, as we have seen, by increasingly frequent legal troubles, brushes with the police, and outbursts of temper and volatility, 1605 was a particularly unfortunate year for the painter.

That summer, he returned from Genoa to find that he had been evicted and was essentially homeless—a peculiar situation for a painter who remained, despite his recent setbacks, among the most celebrated in Rome. The inventory drawn up by the landlady, who repossessed his belongings for nonpayment of rent, is not merely modest but grim: He owned two beds, a few simple pieces of furniture, some kitchen items, ragged clothes, studio props, weapons, a guitar, twelve books, and some art supplies. Bellori tells us that Caravaggio liked expensive clothing but that once he put on an outfit, he wore it until it was in tatters. He paid only minimal attention to personal cleanliness, and for many years he used the canvass on which he'd painted a portrait as a tablecloth and ate off it, day and night.

Far more worrisome was the fact that Caravaggio seemed to be having trouble completing his commissions on time, or at all. He had contracted to do some paintings for the duke of Modena, but a series of letters from Fabio Masetti, the duke's agent in Rome, describe Masetti's futile attempts to extract the promised work. First he reports, somewhat balefully, that he is unable to obtain the pictures since Caravaggio, as a consequence of his assault on the notary, is currently in Genoa, a fugitive from justice.

Masetti appealed to Del Monte for help, and, in a famous letter, Masetti repeats Del Monte's description of the painter as having an

extreme and erratic personality—literally *un cervello stravagantissimo* (a most extravagant and unruly head). To prove his point, Del Monte described how Caravaggio had refused an offer of 6,000 *scudi* to paint a loggia for the Principe Doria. This decision must have seemed even more puzzling to Masetti when, twice during the next few months, Caravaggio turned up at his door to beg for an advance—first of 12 *scudi*, then of 20 more—against the 50 or 60 *scudi* that he had agreed to charge the duke of Modena for his work.

Much later, after Caravaggio fled Rome, Masetti continued to write a long series of heartfelt and almost comical letters in which he assured his employer that, even though the painter has committed a murder and left the city, the agent had not slackened in his efforts to obtain the promised paintings, or at least to recover their 32-*scudi* advance.

Throughout that difficult year of 1605, the downturn in Caravaggio's fortunes seems to have increased his determination not only to stick to his principles but to see how far he could take them, how hard and how recklessly he could push against the increasingly straight and narrow confines of orthodoxy. His work became even more provocative and outrageous, almost as if he were testing the limits and the patience of the patrons who had engaged his services.

And so, in the late autumn, after years of wishing to be included among the artists hired to work on Saint Peter's, after years of resenting those—among them, Il Pomarancio, Domenico Passignano and Lodovico Cigoli—who were employed in the ongoing redecoration of the basilica, Caravaggio was commissioned by the Archconfraternity

of the Palafrenieri (the papal grooms and horse guards) to paint an altarpiece for their chapel in Saint Peter's. The painting was supposed to depict the Virgin, the Christ Child, and Saint Anne, the patron saint of the Palafrenieri. Furthermore, the image was meant to illustrate the doctrine, formally established by Pope Pius V in 1569, that Christ and Mary were equally responsible for the eradication of original sin. This ruling was intended to address and combat heresies such as that of the Protestants, who believed that the credit for man's liberation from the consequences of Adam and Eve's fall was due solely to Christ, and not to his mother.

In the painting, the Virgin, dressed in a red, low-cut gown rucked up to reveal a dark skirt, bends over to support her young son. Christ is a fair-haired, unusually tall, naked boy of two or three. He is old enough and so naturalistically rendered that his nakedness seems startling, sexual, denuded of the innocence we are used to associating with the holy infant. Indeed, there is nothing beside the dramatic situation of the painting to distinguish him from any other little boy or to identify him as Our Lord and Savior.

Mary's hands tenderly cup the sides of Jesus's chest, just beneath his armpits, steadying and bracing his tense, energized, and slightly off-balance little body. Besides them stands Saint Anne, an old woman in a coarse gown, whose gaze helps direct our own to the bottom of the painting, where the baby's bare foot rests on his mother's bare foot as, together, they apply their weight and force to the presumably critical spot directly behind the head of a serpent that twists, coiling up off the ground. All three figures are looking at the snake, and we need their direction, because, without (and even with)

their help, our attention tracks first to the Virgin's radiant face, then to the bright flash of white paint on the body of the snake, and finally—or perhaps it is what we have noticed first and have required a moment to process—to the little boy's penis, very much at the center of the trio of figures, and again so realistically depicted that it casts its shadow on the boy's thigh.

Even today, regardless of how sophisticated and knowing we imagine ourselves to be, the painting still has the power to make us look and then look again to see if we are really seeing what we think we are seeing. How did Caravaggio expect the Vatican grooms to react? What precisely did he think they would do when he delivered the painting in the early months of 1606 and collected his modest fee of 75 *scudi*?

Once more, Caravaggio's painting was rejected—owing, says Bellori, to the vile portrayal of Virgin and the naked Christ Child. Baglione adds that the cardinals in charge of Saint Peter's ordered it removed from the church. In addition, it was decided that the grooms would not be given their own altar in the main portion of the church, and they were later assigned a chapel in a less central part of the basilica.

On the night of Sunday, May 28, 1606, two men—both soldiers, both Bolognese, both armed and up to no good—loitered in the Via della Scrofa near the tennis courts. They were waiting for something to happen, a fight about which they'd been warned. At least one of the men had agreed or been hired, as he said, *to perform a service.*

Late May can be very hot in Rome. It had already proved to be

an unusually troubled and restless night. A celebration with fireworks and parades to mark the anniversary of the pope's coronation had degenerated into chaos and violence. A man had been murdered in a fight along the banks of the Tiber, not far from the spot where the pair of thugs—a guard at the papal prison and his one-eyed companion—anticipated the moment when rival gangs would meet, and Caravaggio's crew would battle Ranuccio Tomassoni's.

The Tomassoni were a family of street fighters and neighborhood bosses, the *caporione* of the Campo Marzio, Caravaggio's neighborhood. Their forebears had a military history illustrious enough to justify the clan's distinguished social status, which involved a mix of outright criminality and political clout. They functioned as guards, as private armies, and as the strong right arm for such influential families as the Aldobrandini, the Farnese, and the Crescenzi. Ranuccio Tomassoni had been the lover of Fillide Melandroni, the courtesan who had modeled for Caravaggio, and who had attacked another woman she believed had stolen Tomassoni's affections. It was said that the ill will between Caravaggio and Tomassoni had something to do with Fillide. Depending on who was testifying in a series of criminal actions, Onorio Longhi had been a friend or an enemy of Ranuccio Tomassoni's, and over the years the two men had a number of hostile and violent confrontations.

So, too, with Caravaggio, the line between friend and enemy could shift suddenly and without warning. Not long before the night of the twenty-eighth, a feud had erupted between Caravaggio and Tomassoni, a dispute that had some connection to a game of tennis.

The detail of the tennis game clings persistently to the event. But

like so much of what has come down to us about the life of Cara-
vaggio, the story of the tennis match has survived in a number of
variant forms. Everyone (not just the early biographers, but also the
professional clerks who wrote the first *avvisi*, or official notices)
seems to have heard or imagined something slightly different, or to
have concocted his own version of the crime according to a personal
recipe of hearsay, fantasy, and truth.

In a letter from one of the duke of Modena's representatives in
Rome, the fight is described as having broken out over a disagree-
ment about a tennis game that Caravaggio and Tomassoni were ac-
tually playing together. Something akin to that idea must have
influenced Bellori's contention that part of the struggle involved the
two men beating each other with tennis rackets. According to the
best known *avviso*, written three days after the fight, the cause of the
disagreement was a bet on a tennis game, a wager in which Tomas-
soni had won ten *scudi* from Caravaggio. Another *avviso* confirms
the story about the bet, and goes on to say that Caravaggio indig-
nantly refused to pay the ten *scudi*.

It was not a light or casual wager, especially when we consider
how Caravaggio's fees had decreased. He had received a mere 75 *scudi*
from the Palafrenieri and was planning to charge the duke of
Modena 50 or 60 *scudi* for the work he would never deliver. Mean-
while, as we have seen, he had come to beg the duke's agent for two
advances—the first of which was for only 12 *scudi*. And all this was
around the time that he had been evicted, and was homeless, and had
had his belongings repossessed.

Consequently, the initial conflict and the fight that evolved were

about more than honor, temper, and indignation. Ten *scudi*, the amount of the bet, must have seemed a considerable sum to a man struggling for his economic survival. And it provided an excellent excuse for a fight to a man who seems never to have required much of a reason for violence.

The tension had led to conflict a few days before the twenty-eighth, the night on which, as everyone involved seemed to know, the dispute would be settled. Each side would consist of at least four men, though one *avviso* claims that twelve were involved. And the two Bolognese had been conscripted to round out the numbers for the painter and Onorio Longhi, Caravaggio's friend and longtime partner in crime.

None of this was spontaneous. It was not the result of a quick, hot response, a lightning flash of temper. It was almost balletic, so carefully choreographed and staged that, like so much of Caravaggio's life, it evokes Shakespearean drama.

On the night of May 28, Caravaggio and his little band swaggered past the house of Ranuccio Tomassoni, in the Piazza di San Lorenzo in Lucina. And Ranuccio's gang, which included his brother Giovan Francesco and two other family members, rose eagerly to the challenge.

Violent struggles are of course difficult to observe clearly, to recall, sort out, and describe with accuracy. But there seems to have been a rare degree of concurrrence about this one, though Baglione presents Ranuccio as the "very polite" victim of a sociopath always on the lookout for a chance to risk his own life or endanger someone else's. According to Baglione, Ranuccio fell to ground after Car-

avaggio had stabbed him in the thigh. Only then did Caravaggio finish him off. Mancini takes the opposite view, claiming that Caravaggio was defending himself when the death occurred.

Ranuccio and Caravaggio fought, one on one. Caravaggio was wounded, and the Bolognese captain came to his aid. Finally, Ranuccio tripped and faltered. And Caravaggio killed him.

It took two days before the wounded artist was well enough to leave the city. During that time, the last he would spend in Rome, he hid, probably in the palace of the Marchese Giustiniani. His injuries could not possibly have healed by the time he fled, by most reports to the Alban Hills, where he stayed under the protection of the Colonna family.

Until the end of that summer, he remained in the vicinity and painted, doubtless out of some combination of the compulsion to keep working and the need to stave off a financial emergency. One of the canvases he completed was a Mary Magdalene, her head tipped back, one shoulder bared, gestures reminiscent of the boys he had painted for Del Monte. But the Magdalene's central prop is not a lute but a skull, and she projects the opposite of coyness and seduction. The power of remorse and regret has rendered her nearly unconscious, taken her so far outside herself that she is bordering on the ecstatic. The painting reads like a barely encoded message to God and to the world: an image of Christianity's most exemplary penitent depicted by a sinner who has every reason to long for forgiveness from heaven and from the state.

Again, unlike the luscious Magdalenes who make you think first

of the ways in which they have sinned rather than the fervor with which they are repenting, Caravaggio's penitent is almost anti-erotic. For one thing, she has the shoulders of a young man. For another, she has retreated so far from us that, unlike the darling and highly approachable lutenists and fruit bearers in his earlier work, she makes us feel that any attempt to communicate with her, let alone to touch her, would be an insult and an affront.

Caravaggio also did another depiction of *The Supper at Emmaus*, far darker, more serious, and profound than his earlier version. The glossy, umarred Christ has been replaced by one who has suffered, and the pilgrims at the supper are less shocked than moved and touched by this evidence of what Caravaggio himself must have longed to believe: that one can find a miracle and discover salvation at the end of what had seemed to be merely a hard day on the road. But if these paintings had personal and spiritual significance for their creator, they were also intended to secure him the funds that he would need during the uncertain period that lay before him. *The Supper at Emmaus* was promptly sold to another loyal longtime patron, Ottavio Costa.

When autumn came, Caravaggio departed for Naples, which was then under Spanish rule, and which might as well have been a different country. Even today Naples can make you feel as if you have left Italy and been magically transported to North Africa or Asia. The streets of the old city are narrower and more mazelike than those in the capital, and they're darker, shadowed by ancient dwellings that loom like skyscrapers, compared with the relatively

low-rise buildings of Rome. The population was and is poorer and more likely to be unemployed, the prevailing atmosphere more volatile and anarchic.

Happily for the exiled painter, part of what tied the two cities together were the tendrils of influence exerted by families like the Colonnas, who had played such a critical role in Michelangelo Merisi's life, beginning when his father was employed in their palace in Milan. Caravaggio had thoughtfully brought the Neapolitan Colonnas his Mary Magdalene as a gift, and they were proud to introduce him to the local aristocracy and its privileged art collectors. The Neapolitan artists were also thrilled to have in their midst not only a great painter but also one with the glamor of Caravaggio's stature, his reputation, and his notoriety. Perhaps uniquely susceptible for reasons of temperament and natural predisposition, the painters of Naples were drawn to Caravaggism with the zeal of new converts, and for decades afterward, Neapolitan painting would reflect the dramatic lighting and the theatrical scenarios that the master had brought down from Rome and left with them in trust.

Presumably, their admiration for the brilliant newcomer was such that the local painters hardly resented it when, almost immediately, Caravaggio began receiving some of their city's most sought-after commissions. He was hired to paint an altarpiece for the Pio Monte della Misericordia, a church recently constructed by the circle of aristocrats who had formed a confraternity dedicated to performing charitable deeds, to ministering to the poor and the incurably ill. Caravaggio was requested to depict the seven acts of mercy as enu-

merated in the *Gospel of Saint Matthew*: clothing the naked, visiting the sick and the imprisoned, feeding the hungry and giving drink to the thirsty, sheltering the wanderer. He was also directed to include, in the same painting, the Madonna della Misericordia.

The Seven Acts of Mercy was a daunting assignment, but Caravaggio rose to the challenge, setting his nocturnal drama in a cramped piazza and crowding the lower half of his canvas with figures involved in scenarios corresponding to each of the seven good works. The most startling and most brightly lit of these illustrates the ancient Roman legend of Cimon and Pero, an exemplary tale of filial devotion concerning a woman who saved the life of her imprisoned and starving father by nourishing him with her breast milk. Here, in an astonishingly naturalistic touch, Pero has lifted the hem of her skirt as a sort of bib beneath the chin of her grizzled father, whose head protrudes between the prison bars as he suckles her bare breast. Half turning from him, Pero regards the spectacle around her: Samson drinking from the jawbone of an ass, Saint Martin dividing his cloak to clothe a naked beggar, an innkeeper directing pilgims to his establishment. Just behind Pero, a priest raises his torch to aid a man grasping the ankles of what appears to be a corpse. Above it all soars Mary, tenderly holding her radiant child, and from a tangle of angels, feathered wings, and swirling drapery, she surveys the world beneath her with perfect and absolute compassion.

Lacking a central emotional core, a vibrantly intimate interaction of the sort that allowed Caravaggio to achieve his most powerful effects, the painting seems chaotic, almost circuslike, and unfocused.

It's hard to know what we should look at first, or what impression we should take away from this jittery, hyperactive carnival of competing activity—that is, until we realize that what we are seeing is Naples itself. Even now the darkness, the light and shadow, the frenetic buzz of the crowd makes the altarpiece seem less like a biblical or mythical narrative than like a cityscape, like reportage.

In the heart of the city's historic center, the Church of Pio Monte della Misericordia is directly around the corner from the Duomo, and on one of the busiest blocks of the ancient road that has become the terrifyingly and thrillingly congested Via dei Tribunali. The modestly proportioned church's vaguely beehive-like shape makes you think, for just a moment, of a church by Francesco Borromini. But as you step into the circular, whitewashed interior, that one moment of peace and reflection is all you can hope to get before Caravaggio's masterpiece draws you in and makes you feel as if the vertiginous and endlessly fascinating street life of the *centro storico* has somehow followed you inside. It's a kind of magic, really, a miracle of transformation—to have set out to depict the seven faces of charity, and to have painted, in the process, an impressionistic portrait of an essentially unforgiving and recklessly passionate city.

Once more we can watch Caravaggio testing the aesthetic boundaries and the squeamishness of his patrons, juxtaposing the audaciously highlighted naked breast of the ordinary Neapolitan woman who modeled for Pero with the bare feet of the corpse on its way to an unceremonious burial. But this time the artist was not disappointed. The painting pleased its intended audience, the Confra-

ternity of the Misericordia and the faithful who came to worship in their church. It must have been a great comfort to Caravaggio, after his troubles with the altarpieces he had painted in Rome, which had been rejected.

He was soon receiving other commissions from yet more Neapolitan patrons, most importantly for a portrayal of *The Flagellation of Christ*, destined for the chapel of the di Franco family in the Church of San Domenico Maggiore. In reimagining the scene of the flagellation, Caravaggio was returning—after the complications and the mass chaos of *The Seven Acts of Mercy*—to the sort of image at which he excelled: a simple drama in which the innocent victim, the object of our religious veneration as well as our human sympathy, is pitted against his torturers or assassins in such a way as to extract the maximum emotion from a wrenching and tragic scene.

The flagellation was a perfect subject for Caravaggio, an occasion and an invitation for him to pull out all the stops. The scene is one that pious Christians have often been encouraged to meditate on as a means of releasing all their pity and grief for the scorned and tormented Jesus. In the Church of Santa Prassede in Rome is a section of the whipping post to which, it is claimed, Christ was bound during his scourging. One afternoon, I watched a monk kneeling in front of the relic, praying and weeping steadily for well over an hour.

The Flagellation of Christ is one of Caravaggio's most beautiful and saddest paintings. Naples's shadows have changed him. His blacks have never been blacker. Much of the canvas is given over to dark and empty space. The drama is transpiring in a grim Neapolitan dungeon

in which there is nothing, where nothing *exists* but the column to which Christ is tied. Light shines from the pillar, and from Christ's as yet unblemished chest. The beauty and brightness of his flesh only serve to remind us of how soon it will show the bruises and excoriations, the physical and visible evidence of his pain and humiliation. Every muscle, every cell in his perfect young body has tensed in order to ward off the pain as he twists away from his attackers. Already a few smears of blood testify to the harshness with which the crown of thorns has been jammed onto his forehead. And Christ has already drawn inside himself. His eyes are closed, his head tilted, his chin half tucked under his shoulder in the way that a bird might nestle its head beneath its wing.

In some ways, the painting resembles *The Crucifixion of Saint Peter* in the Cerasi Chapel in Santa Maria del Popolo. Both depict the moment of suffering before the real suffering has begun; both show the solitary victim outnumbered by, and at the mercy of, three executioners or tormentors. But the difference between them shows us how much darker and more desolate Caravaggio's vision has grown.

The laborers hoisting Peter's cross take no pleasure in their work. Their faces are hidden from us, as if to allow them to perform their assigned task in private. They are simply doing a job on someone else's orders. The same might be said of the man who kneels in the lower left corner of *The Flagellation*, efficiently and unhurriedly tying the bundle of branches with which he will soon begin to beat Jesus. Likewise, the workman on the right seems to be engaged, with no

particular malice, in tightening the ropes that bring Jesus's wrists to the column. But that impression changes when you notice the detail of his foot, pressing for leverage into Christ's calf—an act of gratuitous cruelty, or at best of the most egregious sort of unconciousness. For we can safely assume that the same force and leverage could have been achieved had he braced his foot against base of the column and not felt compelled to step on Christ merely because he could. And there can be no doubt about how much the jailer on the left is enjoying his task. His eyebrows are raised, his teeth bared in a grimace of sadistic satisfaction as he yanks Jesus's hair, a brutal gesture accentuated by the sweet and melting angle at which Christ inclines his head.

In many paintings of the flagellation, the beating of Christ seems to have an almost balletic aspect; in their enthusiasm, the torturers draw back and twist their bodies to intensify the force of their blows. So perhaps what makes this version so painful to behold is, again, the realism with which labor is portrayed; what's transpiring here is not dancing, but rather a perversely rewarding form of hard labor.

In his religious paintings, beginning with *The Martyrdom of Saint Matthew* and even *Judith and Holofernes*, Caravaggio had never shied away from telling the truth about what human beings will, given half the chance, do to one another. But not until *The Flagellation of Christ* did he reveal what he knew, or suspected, about how much they enjoy it.

<center>* * *</center>

In the summer of 1607, Caravaggio left Naples for Malta. Like the motives behind so much of what he did during those final years, his reasons for leaving remain mysterious and confounding, especially since his work was so avidly desired and so well received in Naples. Perhaps, as Bellori believed, he was driven by the ambition to be knighted and to receive the Cross of Malta. Perhaps he imagined that, as a knight, he would find it easier to get the pardon that would enable him to return to Rome. Perhaps he went in the hopes of receiving a commission to decorate the new Co-Cathedral of Saint John in Valletta, though that seems improbable, since he was already getting so many lucrative assignments in Naples, which must have seemed so much more enjoyable, entertaining, and lively than Malta—that peculiar and isolated island dominated by the militaristic, officially austere, but in reality (at that time) increasingly dissolute and contentious Knights of the Order of Saint John. Or perhaps the isolation was exacty what appealed to him, perhaps in his growing and possibly justified paranoia, he believed that the papal authorities were still after him, and that they remained so determined to bring him to justice for the murder of Ranuccio Tomassoni that Naples suddenly seemed dangerously close to Rome.

Or perhaps he had once again managed to get into some sort of ugly entanglement, to become embroiled in a feud that had not yet attracted the attention of the authorities, but that threatened to erupt into a new version of the disaster that had forced him out of Rome. Perhaps this time it seemed wiser to leave town rather than to simply let matters take their perilous and inevitable course. Given his char-

acter, this supposition hardly seems unlikely, and certainly, when he revisited Naples two years later, some old trouble was waiting for him or some new trouble came to find him, and he was attacked and nearly killed in a fight in a tavern.

The least probable explanation is that offered by Sandrart, who claims that Caravaggio was still smarting from the insult he had received from the Cavaliere d'Arpino, who had refused to fight him because d'Arpino was a knight and Caravaggio wasn't. At this particularly stressful and turbulent period in his life, claims Sandrart, Caravaggio was driven by the determination to bump his social status up to the level of his former employer's. Sandrart seemed convinced that the quarrel with d'Arpino was such a watershed moment for Caravaggio that, as soon as he was knighted, the artist rushed back to Rome to have things out, this time on an equal footing with his former rival.

In any event, Caravaggio was living in Malta by the end of July. The society in which he found himself could hardly have been more different from the sybaritic aristocracy and the anarchic street life of Naples or, for that matter, from the artistic and political intrigues of Rome. Malta was essentially a military outpost manned by a religious volunteer army, a thickly walled fortress in which the Knights of the Order of Saint John had taken on the sacred duty of protecting Christendom and Western Europe from the onslaughts of the Ottoman Turks and, after the Battle of Lepanto in 1571, the Barbary pirates.

By the time Caravaggio arrived, many Maltese could still re-

member the Great Siege of 1565, when the Ottomans had filled the waters of the harbor with the headless bodies of dead knights tied to a flotilla of crucifixes that carried them, like rafts, toward shore. And the knights had retaliated by firing the heads of the dead Turks from cannons. Since then, captured Christians had been sold into slavery by the Turks, just as Turkish prisoners were made to work as galley slaves on European ships.

Malta's position at the center of a thriving slave market did little for its moral character, and it was common for the knights to have slaves as personal attendants. Nor was the tone of the place improved much by the influx of prostitutes who came to service the predominantly male society of merchants, traders, and theoretically celibate knights. In 1581, the knights revolted and imprisoned their grand master, Jean de la Cassiere, who had made the tactical mistake of attempting to expel the whores from the island.

In the newly built baroque city of Valletta, Caravaggio's circle most likely included Marc'Aurelio Giustiniani, a relative of the painter's former patrons in Rome, and Fabrizio Sforza Colonna, whom the pope had sentenced to exile in Malta as a convenient solution to the embarrassing problems caused by the awkward conjunction of Colonna's lineage, his popularity, his fame—and his criminal activity. Most important, Caravaggio enjoyed the support of the current grand master, Alof de Wignacourt, an aristocratic Frenchman who had become grand master in 1601, and whose architectural, civil, and cultural achievements included the building of the Tower of Malta, the construction of the aqueduct that furnished Valletta with

its water supply, and the establishment of the National Library. Surely it must have been clear to everyone involved that Wignacourt's favor would prove to be Caravaggio's ticket to knighthood.

Taxing their imaginations to understand how the undeserving, lowborn Caravaggio could have received an honor designated for the favorite sons of the aristocracy, Bellori, Baglione, and Mancini come together in a rare moment of concurrence. All three suggest that the artist's knighthood was essentially granted him in return for the portrait or portraits (Bellori claims there were two) he painted of the grand master, which pleased Wignacourt so much that he admitted their creator into his order. Perhaps Bellori, like quite a few others who came after him, incorrectly assumed that Caravaggio's portait of another Knight of Malta, Fra Antonio Martelli, was also a likeness of Wignacourt.

Looking at these portraits—both depictions of old men—you may find yourself regretting how many Caravaggio portraits have been lost, for both of these paintings are among art history's most psychologically complex, astute, and sensitive renderings of the ways our physical appearance discloses all manner of information about our character and experience, even as it vigilantly guards our deepest secrets.

Like the portraits by Titian, Rembrandt, and Velasquez, the depiction of Alof de Wignacourt precisely calibrates the formula of just how much the face is compelled to reveal and how much it declines to tell us, so that we may think that we know something about its owner until we are forced to agree with Virginia Woolf that you can never say that a person is this or that, one thing or another.

Meanwhile, we can't help drawing our own conclusions about the sitter. Positioned in the center of the canvas, the grand master wears his heavy and elaborate armor as comfortably and magisterially as a metal suit can be worn. His stance conveys authority and control, he stands as if he owns the ground beneath his feet. His bearded, close-cropped head is turned to one side, his gaze tracks into the distance—perceptive, shrewd, but neither inhuman nor intimidating. He is proud of himself and of what he's accomplished in the course of his sixty-one years, but there is something about him that resembles all those old men, humbled by time, who appear so often in Caravaggio's work. Though the portrait makes no attempt to make him look younger than he is, it thoughtfully conceals some of the fleshiness, and equivocates slightly about the size and shape of his nose, as well as the wart growing on it—features that other portraits of the grand master confronted more directly.

The painting could almost pass for a traditional military portrait, an unusually conventional effort from Caravaggio, which is understandable, since even the fiercely uncompromising painter doubtless understood that this time something more than pure art was at stake. But Caravaggio never disappoints, never settles for what is familiar or expected. The grand master is not alone. On the right of the canvas stands a page boy, a pretty blond youth of ten or so, carrying Wignacourt's plumed helmet, which is made to appear doubly enormous by the fact that it seems to be twice the size of the boy's head. Why is the little servant in the painting at all? And why is he staring out at us so fixedly that he is constantly on the edge of upstaging the grand master? What is he—and Caravaggio—trying to tell

us? What is the boy's relation to the older man? Should we let ourselves register the fact that the boy is of the age that, in those times, would have been considered most appealing and most suitable as a romantic object for a man of Wignacourt's age?

The answers, which we will never have, are finally not what matter. The boy provides that singularly distinguishing detail—the bare feet of the pilgrim, the swollen belly of the Madonna, the gnarled legs of the saint, the jailer yanking Christ's hair—that so neatly combines reality and mystery in a single image that Caravaggio searched for and could not resist representing, and that identifies his presence and his vision as conclusively as a fingerprint.

It's impossible to say if events occurred in the order and for the reasons that Bellori believed. We may never know whether Caravaggio was really hired to paint *The Beheading of Saint John the Baptist* for the oratory of the Co-Cathedral of Saint John in Valletta because the grand master was so delighted by his portrait. But it's not unreasonable to suppose that the Maltese, who in all likelihood had never seen any of Caravaggio's paintings, might have wanted some small indication of what he could do before they asked him to create the massive altarpiece, which, measuring almost twelve feet tall and more than seventeen feet wide, was to be his largest work.

The composition of *The Beheading of Saint John the Baptist* marks a daring departure that would become characteristic of his last religious paintings—depictions of miracles, or of their preludes or aftermaths, transpiring in what appear to be the depths of an abyss. In these works the figures are crowded into a narrow band at

the bottom of the painting, beneath a crushing expanse of space as weighty and earth-toned as the dirt under which, as every brush stroke reminds us, we will all be buried before too long. Bellori tells us that, in painting *The Beheading*, Caravaggio employed the full power of his brush, working so rapidly and fiercely that the canvas shows through the halftones.

Everything of importance is happening in the lower left of a dismal streetscape that, alone in Caravaggio's work, is based on an actual location: the entrance to the grand master's palace. Nothing but architecture—the stones of an archway, a barred gate—exists to intercede between the grisly scene and the two witnesses on the far right, who are trying to see as much as they can despite the barred window restricting their view. Unlike those Caravaggios in which the worst is about to occur, this painting is set at the moment in which it already has. With his hands bound behind his back, the dead or nearly dead saint is pressed flat, belly down, on the ground. Like his cruel counterpart in *The Flagellation of Christ*, the executioner jerks on his victim's hair, but this time, as in *The Crucifixion of Saint Peter*, it's not so much about casual sadism as it is about business: the business of butchery. The tragedy isn't finished, and lifting the victim's head is simply a way to facilitate what will happen next.

As blood streams from John the Baptist's neck, the executioner reaches behind his own impressively muscular back for the dagger with which he will complete the tough part of the beheading. So maybe the worst *is* yet to come, because decapitation with a dagger cannot be a pretty sight. Yet no one—except an old woman who puts

her hands to her face in horror—seems to mind terribly much. They all have a job to do.

Years earlier, staging *The Calling of Saint Matthew*, Caravaggio discovered how a pointing finger can focus our attention, and now the finger is that of the warden who indicates the platter that Salome (not the familiar, veiled seductress but an ordinary young woman with her sleeves rolled up in anticipation of the messy chore before her) has just bent to pick up. The chilly impassivity of the warden's gesture is so disturbing and compelling that it draws our eye and holds it until we can detach ourselves long enough to search for the saint's body, or for the signature, in the Baptist's red blood: *f. michel*—that is, Brother Michelangelo. This proud declaration suggests that by the time the painting was installed, its creator was already a Knight of Malta. And the connection that Caravaggio is drawing between paint and blood, an association that recalls his *Judith and Holofernes*, has a deeper, more autobiographically resonant—and more moving—significance than it did in the earlier painting.

Luckily for history, the Order of Saint John believed in the value of archival documentation, and a series of official notices track Caravaggio's brief and characteristically dramatic career as a *cavaliere*. Indeed, among the holdings of the archiodese of Malta is an anonymous oval portrait of Caravaggio, beneath which is the legend: FR. MICH/ ANGELUS MERISIUS/ DE CARAVAGIO. The sitter, who has dark hair, a mustache, and a goatee, is wearing a cloak on which we can see a part of his Maltese cross. Instantly recognizable from the cameo self-portraits in his religious paintings, Caravaggio

looks dissatisfied and angry; his mouth is downturned and pouting. But the portrait makes you wish that it had been done by someone with a gift that even remotely approached the genius of his subject. The painting tells us little that we couldn't have surmised on our own from the facts of Caravaggio's life or from his own visual self-representations.

At the end of December 1607, six months after Caravaggio sailed to Malta, Grand Master Alof de Wignacourt wrote to his ambassador to the Holy See, asking his emissary to sound out the pope on the subject of knighting two unnamed persons, one of whom who had committed a murder during a fight. The letter expressed the grand master's hope that knighthood would persuade this anonymous person to remain in their community, a decision that, given Caravaggio's prestigious reputation, would have represented a coup for the order. In February, an exchange of letters between Wignacourt and Pope Paul V secured papal permission for the still unnamed murderer to be knighted despite his crime, together with the second person alluded to in the previous letter, a French nobleman whose illegitimacy was considered far more problematic than a mere homicide or manslaughter.

Finally, on July 14, 1608, approximately a year after his arrival in Malta, Michelangelo da Caravaggio was made a Knight of Obedience, a category of knights who were not obliged to take monastic vows. The official document explains that the pope had given his approval and leaves no doubt about why Caravaggio was being so honored—because the order welcomed not only aristocrats but also men

with great artistic and scientific ability. It was hoped that the goal of knighthood would encourage men to apply themselves to these important pursuits. The cross and the belt of the Order of the Knights of Saint John were conferred on its newest inductee, and according to Bellori, Caravaggio was also given a gold chain and two slaves.

With his gold chain and his knighthood, Caravaggio could have taken some satisfaction in the thought that he was finally on an equal footing with his old rivals, Baglione and d'Arpino. And, Bellori claims, Caravaggio was extremely happy to receive the Maltese cross, to have his work so enthusiastically appreciated, and to live with so much personal dignity and such an abundance of good things.

But no one who knew Caravaggio could have imagined that this interval of happiness and tranquillity would last. Indeed, less than three months after his induction into the order, yet another official notice records a catastrophic downturn in his fortunes. Having been incarcerated in the Castel Sant'Angelo, he had somehow escaped Valletta's unimpregnable fortress-prison and had left the district without permission—in itself a crime sufficiently serious to deprive a knight of his membership in the order. Two knights were assigned to search for him, to bring him to justice and to find out how he had managed to achieve the impossible.

The investigators delivered their report, which has since been lost. Later, it was claimed that a rope had been used in the escape, but no one has ever been able to discover exactly how Caravaggio pulled off his phenomenal disappearing act, or who helped him—or, for that matter, what got him thrown into prison in the first place.

Given what we know about Caravaggio's history and personality, the most plausible theory about his fall from grace is that he got into a dispute with a fellow knight, and that his temper and hair-trigger sensitivity caused him to forget that the Brothers of Saint John were strictly forbidden to fight one another. That is what Bellori and Baglione thought. As a result of what Bellori diagnosed as his "tormented nature," Caravaggio, he claimed, got into an ugly disagreement with a Knight of Justice.

It is at this point that another voice joins the chorus of early commentators on Caravaggio's life. Francesco Susinno, the priest whose *Lives of the Messinese Painters*, published in 1724, tracks Caravaggio from Malta through Sicily and then on his final journey to Naples and toward Rome, tell us that wearing the Maltese cross on his chest not only failed to ennoble Caravaggio but gave him the delusion that he *was* a nobleman. In a display of markedly unknightlike behavior, he got into a sword fight with a *Cavaliere de Giustizia*. Imprisoned by Wignacourt, he somehow succeeded in scaling the prison wall and escaping to Sicily.

Summonses and proclamations, propagated throughout Malta, failed to turn up any sign of the vanished painter. And on December 1, a general assembly met to expel Michelangelo Merisi da Caravaggio from the Order of the Knights of the Brotherhood of Saint John.

Convened in the oratory in which *The Beheading of Saint John the Baptist* had so recently been installed, the ceremony was calculatedly portentous. Four times Caravaggio's name was called, and each time

the fugitive failed to appear. The hearing ended in a unanimous and irrevocable verdict: Brother Michel Angelo had been deprived of his habit and thrust forth from the order and community "like a rotten and putrefying limb."

But by then, Caravaggio was already safe—or apparently safe—in Sicily. There, in the ancient Greek city of Syracuse, he was reunited with Mario Minniti, the roommate with whom he had most likely shared living quarters in Del Monte's palace, and the model for the pink-lipped, curly-haired, smooth-skinned boy who appears in so many of Caravaggio's early paintings for the cardinal.

After returning to his native Sicily four years before, Minniti seems to have tried to distance himself from the dissolute life of the Roman streets and the sybaritic pleasures of Del Monte's court. He married, had children, and after an inconvenient interlude involving a murder he committed, most likely in a fight, he was pardoned. Subsequently, he had gone on to become a successful and popular painter.

Minniti must have been genuinely glad to see his old friend, since all his effort seemed aimed at arranging matters so that Caravaggio could remain as long and as comfortably as possible in Syracuse. His endeavors were facilitated by the fact that, once again, Caravaggio's fame had preceded him, and by a rare instance—rare, that is, for Caravaggio—of good timing. In preparation for the upcoming feast day of Syracuse's patron, Saint Lucy, the city government commissioned Caravaggio to paint a large work for the saint's newly refurbished church.

Like *The Death of the Virgin*, *The Burial of Saint Lucy* depicts a group of mourners who have gathered around the body of a dead woman. But Caravaggio seems to have learned his lesson from his experience with the earlier painting. Lying directly on the ground, the delicate, pale Saint Lucy is an innocent and ethereal virgin martyr. Already she has become pure spirit, and nothing about her reminds us of the flesh or of the body that her spirit has so recently departed. No one would ever mistake her for "some dirty whore from the Ortaccio." The ecclesiastical officials and onlookers stand, looking down at her with expressions of sorrow and deep compassion. But though one old woman covers her face with her hands, their grief never threatens—like the pain of those left behind by the Virgin's death—to become too unbearable, too much like our own, to behold.

As in *The Beheading of Saint John*, the entire narrative is crowded into the bottom of the enormous painting that again reflects Caravaggio's lifelong fascination with those who do the physical toil—the stoop labor—of the miraculous. Here they are the gravediggers, one of whom has turned his massive back toward us, as if to shield us from the horror or to hide the shameful deed in which he and his coworker are engaged, except that he has no interest in anything but the spading and digging that must take place before the martyr can be buried. The rippling of his muscles and the pull of the drapery drawn diagonally across his huge buttocks—which, along with the saint's lovely face, her upturned chin, and painfully frail shoulder, catch and reflect the light—are the most animate elements in the

scene, the only things that break the silence and the stillness of the moment.

Saint Lucy is at once the luminous center and the hidden secret of the painting. You have to look for her, to peer around the vital, healthy gravediggers, just as in *The Beheading of Saint John the Baptist*, you have to wrest your attention away from the pointing finger of the warden and the hand of the executioner pulling the saint's hair. Nothing here approaches the brutality and violence of *The Beheading*. Only a clean cut at the base of her throat remains as evidence of how the saint met her death, though in earlier versions the wound was gorier and more bloody. Still, the painting itself seems to have been done with the same furious urgency that caused Bellori to remark on the fact that the raw canvas of *The Beheading* was visible through the halftones.

But though the rendering of Saint Lucy and her mourners may be less provocative and wrenching than that of their counterparts in *The Death of the Virgin*, the painting seems somehow, if possible, even more audacious and moving. What makes it so daring and affecting is the vast expanse of emptiness—of dark, earth-toned space—that occupies the top two-thirds of the painting. If the Virgin was laid to rest beneath a swirl of crimson drapery and a humble beamed ceiling, here there is nothing. No heaven, no cherubs, no angels. Only dirt and earth and darkness. It is hard to think of a bleaker, less comforting painting. But what consoles us is its courage, its truthfulness, and, of course, its great beauty. It's startling to look at *The Burial of Saint Lucy* and to think that it was

painted by the same artist who, less than a decade before, painted those pretty lutenists for Cardinal Del Monte.

Once more, he could have stayed where he was. *The Burial of Saint Lucy* was enthusiastically received by the citizens of Syracuse, where he was entertained by such local luminaries as the famous archaeologist Vincenzo Mirabella, who took him on a tour of the quarries that, it was said, had been used as prisons by the Greek tyrant Dionysius the Elder. One of these caves has unusual acoustical properties: If someone whispers in one corner, it can be heard clearly on the far side of the cavern. Caravaggio, who had spent enough time in prison, and had plenty of experience with paranoia and with the fear of being overheard, christened it "The Ear of Dionysius," a name that immediately spread and by which the cave is still called today.

Presumably, there would have been other commissions from wealthy Syracusans. But by winter, Caravaggio (impelled, Susinno suggests, by his restless, peripatetic nature and by the awareness that nothing is so marketable as the novelty of being a new face in town) had traveled up the coast to Messina. There he was engaged to create an altarpiece for the Church of the Padri Crociferi, an order that ministered to the sick. In honor of his patrons, the Lazzari family, and perhaps in consideration of the venue where his work would be installed, Caravaggio chose as his theme *The Resurrection of Lazarus*.

According to Susinno, Caravaggio requested a room in the Crociferi hospital to use as a studio and was given the best *salone*,

together with the services of several members of the hospital staff, who were drafted to pose for the painting, in which there are thirteen figures. Susinno also claims that, in his uncompromising pursuit of naturalism, the artist insisted that a decomposing corpse be brought in to serve as a model for the dead Lazarus. When the laborers holding the corpse complained about the stench, Caravaggio attacked them with a dagger and forced them to keep working.

It seems an unlikely story. In the painting, only one laborer supports the dead body, which looks more like an emaciated young man than a rotting cadaver. In an effort to make the tale more credible, Susinno cites the rumor (which he himself claims not to believe) that Michelangelo Buonarroti once nailed a man to a board and pierced him with a lance in order to paint a more persuasive Crucifixion.

But another of Susinno's anecdotes seems more plausible and faithful to what we know about Caravaggio's personality. The work-in-progress remained hidden until it was finished. Finally *The Resurrection of Lazarus* was unveiled, and the citizens of Messina—proud of their cultural sophistication and confident in their ability to discuss art intelligently—made a few humble but dim observations that so enraged Caravaggio that he pulled his dagger and cut the canvas to ribbons. Instantly, he reassured his horrified patrons that he soon he would make them an even more beautiful version of Lazarus's miraculous return from the dead. He fulfilled this promise so satisfactorily that the city council of Messina promptly commissioned him to paint another major altarpiece, this time a nativity scene, *The Adoration of the Shepherds*, for the church of the Capuchin

monastery of Santa Maria della Concezione. In return, he received the huge sum of a thousand *scudi*—ironically, a hundred times the amount of the bet that sparked the fatal quarrel with Ranuccio Tomassoni.

Economically, at least, Caravaggio's fortunes had improved since the days when he was begging the duke of Modena's representative for an advance of twelve *scudi*. But the increase in his fees apparently failed to offer the beleaguered painter any sense of comfort or security. He was growing steadily more restless, impulsive, and out of control. The adjectives Susinno employs—*barbaric, bestial, impatient, envious, restless, distracted, foolish,* and *crazy*—would be damning enough, but he takes matters even further, implying that Caravaggio questioned the sacred articles of faith and was suspected of being an unbeliever. His unquiet spirit, says Susinno at one especially lyrical moment, was more turbulent than the sea at Messina with its dramatically rising and falling tides.

Susinno informs us that the painter was always armed and slept with his dagger constantly by his side. And we can also thank Susinno for the disturbing story of why Caravaggio was obliged to leave Messina. Allegedly, he spent his off hours watching schoolboys play near the arsenal, observing and getting ideas from how they moved and positioned their bodies. But when their teacher, a certain Don Carlo Pepe, suspiciously questioned the painter's motives for hanging around the boys, Caravaggio became enraged, hit the teacher on the head—and fled the city. In sum, Susinno tells us, he marked everywhere he went with the imprint of his deranged mind.

From Messina he went to Palermo, where he painted the *Adoration of the Shepherds with Saint Lawrence and Saint Francis* for the Oratorio of San Lorenzo; the work has since been lost. A short time later he left Palermo and returned to Naples.

There is nothing, not one document or report, to shed the faintest light on his motives for leaving the island on which he had found not only new celebrity (he was by now the best known painter in all of Italy) but also where he was receiving the most lucrative commissions of his career. His biographers—that is, all but Mancini—concur: He was in danger, and being pursued, and had to keep moving to remain one step ahead of his enemies.

Susinno says Caravaggio was chased back to Naples by an offended antagonist. Bellori tells us that bad luck did not abandon him, that fear drove him from place to place, and that he left Sicily because he no longer felt safe there. And Baglione writes that he returned to Naples because his enemies were pursuing him. But they are maddeningly unforthcoming about who those enemies were. It's possible that they were wrong, that they were merely seeking a reason for the painter's otherwise inexplicable behavior. Perhaps he wasn't being chased, perhaps he had been led to believe that a papal pardon would soon let him return to Rome, and that Naples represented a stop on the long journey home.

It's also conceivable that he was being followed by a group of vengeful Knights of Malta, and less likely, an official party dispatched by the grand master than agents of the knights whom he had so

grievously offended, and who might have been doubly enraged by the ease with which he had escaped from prison and evaded serious punishment. But why had it taken them so long to pick up his trail and find him?

He was hardly in hiding. His stays in Syracuse and Messina were relatively lengthy, and in both cities he did work that was widely discussed and that added to his fame and reputation. In Messina the patron who financed *The Resurrection of Lazarus* had close ties with a local member of the Knights of Malta. Moreover, Caravaggio consistently presented himself as a knight, conveniently failing to mention the fact that he'd been expelled from the order. In fact the Palermitans apparently believed that the artist who had so briefly graced them with his presence was a Knight of the Brotherhood of Saint John. Perhaps word of that was what finally galled the knights into tracking him down.

Or perhaps it was simpler and less romantic than any of those scenarios. Perhaps he made new enemies everywhere he went, everyplace that, as Susinno said, he stamped with the mark of his madness.

Finally, one grim fact would become clear, beyond speculation or dispute: The danger that Caravaggio believed himself to be in was not merely a figment of his paranoid imagination. A few months after his arrival in Naples, where he was greeted warmly and invited to stay in the grand palazzo of the Marchesa di Caravaggio, he was ambushed by a group of armed men in the doorway of a popular tavern, the Osteria del Cerriglio. In the subsequent attack he was so severely

injured that it was rumored that he had been killed; his face was so deeply slashed and disfigured that he was said to be virtually unrecognizable. Bellori suggests that the Maltese were behind the attack.

This time, Caravaggio's stay in Naples lasted just over seven months, time he spent recuperating and, amazingly, painting. Five of these canvases have survived, three have been lost, and there may have been others for which he received commissions. Understandably the scale of the works is less monumental than that of his great Sicilian paintings. He must have been in pain for part of this period, but, more important, at least some of these works needed to be portable, small enough to be sent or given to those—Grand Master Wignacourt, his former patrons in Rome—whose favor he desperately needed to regain in hopes of procuring help in his quest for a pardon.

Once more, his style changed radically. The bands of figures dwarfed beneath expanses of emptiness give way to claustrophobically intimate dramas of violence, death, and decapitation. The thinly painted earth tones are replaced by glossy, thick black; the dark tones are even darker. The population of the world he portrayed had narrowed to victims and their killers; the expressions on their faces range from indifference to resignation, from exhaustion to remorse, compassion, and grief.

Two of the extant paintings, *The Crucifixion of Saint Andrew* and *The Martyrdom of Saint Ursula*, focus on the moment of death, or, more precisely, on the moment when the inevitability of death is revealed and even desired. Saint Ursula stares down with sorrowful de-

tachment at the sword wound that her murderer has just inflicted; behind her stands Caravaggio, in a pose almost identical to that in which he portrayed himself in *The Taking of Christ*. But whatever seemed excited or curious in the former self-portrait has disappeared, and the expression on the painter's face is that of someone barely managing to hold back tears. The saint at the center of *The Crucifixion of Saint Andrew* is so close to death—already his eyes have taken on a milky vacancy—that the soldier and the two onlookers at the bottom right of the canvas seem to be trying, as we are, to figure out if the old man is still alive.

Among the paintings that remain from those final months in Naples, two more focus on the aftermath of a beheading. Grief and guilt stream from the three figures—Salome, a servant, and the executioner—pictured in *Salome Receiving the Head of John the Baptist*. Unable to bear the sight of what she has done, Salome turns from the saint's severed head, while the old woman and the executioner contemplate it with such horror and pity that, though they could hardly be physically closer, they seem to be looking on from a great distance: the span between life and death.

Perhaps the most powerful and personal work that Caravaggio completed during his final months in Naples is his *David with the Head of Goliath*. Everything that Caravaggio knew about youth and age, cruelty and compassion, life and death, sex and suffering, has been poured, without hesitation or holding back, into this image of the delicate boy—probably the same one who modeled for the brooding *Saint John the Baptist* now in Rome's Galleria Borghese—

holding, at arm's length, the head of the the bearded, shaggy, middle-aged man whom he has slain. The head of Goliath is Caravaggio's last self-portrait. His features are thick and misshapen. One of his eyelids droops. On his forehead is a bloody wound, presumably the mark of the fatal stone from David's slingshot, but which also suggests the disfiguring injuries the painter received when he was attacked at the Osteria del Cerriglio in Naples.

It is, we find ourselves thinking, the face of a man so reckless and desperate that, just a short time later, he would imagine that it was possible to travel in the heat of July, through the miles of swampland that separated Palo (the port where he was detained in prison) from Port'Ercole, and that he could walk from there to Rome. Death has already frozen Goliath's features into a rigid, Medusa-like mask, and what's most disturbing is that death has given him no peace, no relief, no release from the agony and horror of his dying moments, from the shock of having been murdered by a boy so much like the youths whom, in more peaceful and less desperate times, Caravaggio would have loved.

By that summer, the welcome news had reached Naples: Caravaggio had been pardoned, thanks in part to the intercession of two powerful cardinals, the art collector Scipione Borghese, and Ferdinando Gonzaga. Caravaggio was still, or still felt himself to be, in danger, threatened by the Maltese or possibly the Spanish. But with the promise of Gonzaga's protection, he appears to have felt safe enough to undertake the journey to Rome.

In a small boat, a two-masted felucca, the painter set sail from Naples. The ship stopped briefly in Palo, at that time a desolate outpost between Civitavecchia and Rome. It was there that the painter was probably mistaken for someone else, arrested by the Spanish soldiers, and detained until after the felucca had sailed away. Released from prison, Caravaggio set off in pursuit of the boat, which had gone on to Port'Ercole with his paintings on board, canvases he desperately needed as gifts for the influential Romans who had arranged his pardon.

As Bellori commented, "Bad luck did not abandon him." Caravaggio resolved to catch up with the felucca in Port'Ercole, to travel sixty miles up the coast in the blistering heat of summer, and to retrieve his paintings. And so began the last in the series of mishaps that, this time, ended in death—a lonely and miserable death, most likely in the infirmary of the pretty fortress town of Port'Ercole, a town that has now become a fashionable and popular seaside resort.

Like so much else about Caravaggio's life, even his last hours have become the subject of fervent debate. It has been claimed, for example, that he didn't die of natural causes—of malaria—but that he was murdered by the Knights of Malta. But the documents that have been discovered make this theory seem improbable.

As soon as reports of Caravaggio's death reached Rome, his collectors—principally cardinal Scipione Borghese—became obsessed with the fate of the lost paintings. Several works were discovered in Naples, while some were found in the possession of the prior of Capua, who had seized them on the grounds that they were the

rightful property of the Knights of Malta. Eventually, Borghese secured the *Saint John the Baptist* that is in the Galleria Borghese, and by 1613, he had also, in his collection, the magnificent *David with the Head of Goliath*.

Even on the quietest of days at the Galleria Borghese in Rome, there is always a crowd around the image of the brooding young David holding the severed head of the murdered giant. From the canvas, Caravaggio's face—weary, tormented, injured—confronts us with such magnetic intensity that it's hard not to be drawn in, hard not to lose ourselves in the rough beauty of his haggard features.

All these centuries later, the sense of connection, of communi-cation—of communion—that we feel with the long-dead painter seems almost vertiginously direct and profound. Having spent his brief, tragic, and turbulent life painting miracles, he managed, in the process, to create one—the miracle of art, the miracle of the way in which some paint, a few brushes, a square of canvas, together with that most essential ingredient, genius, can produce something stronger than time and age, more powerful than death.

Bibliography

Askew, Pamela. *Caravaggio's Death of the Virgin*. Princeton, N.J.: Princeton University Press, 1990.

Brown, Beverly Louise, ed. *The Genius of Rome*. London: Royal Academy of Arts, 2001.

Christiansen, Keith. *A Caravaggio Rediscovered: The Lute Player*. New York: Metropolitan Museum of Art, 1990.

————and Judith Mann, eds. *Orazio and Artemisia Gentileschi*. New York: Metropolitan Museum of Art, 2001.

Dean, Trevor, and K. J. P. Lowe, eds. *Crime, Society and the Law in Renaissance Italy*. Cambridge, England: Cambridge University Press, 1994.

Freedberg, S. J. *Circa 1600: The Revolution of Style in Italian Painting*. Cambridge, Mass.: Harvard University Press, 1983.

Friedländer, Walter. *Caravaggio Studies*. Princeton, N.J.: Princeton University Press, 1955.

Bibliography

Gilbert, Creighton E. *Caravaggio and His Two Cardinals*. University Park: Pennsylvania State University Press, 1995.

Hibbard, Howard. *Caravaggio*. London: Thames & Hudson, 1983.

Hinks, Roger. *Michelangelo Merisi da Caravaggio*. London: Faber & Faber, 1953.

Langdon, Helen. *Caravaggio: A Life*. New York: Farrar, Straus & Giroux, 1998.

Macioce, Stefania, ed. *Michelangelo Merisi da Caravaggio: La Via e le Opere Attraverso i Documenti*. Rome: Logart Press, 1995.

Magnuson, Torgil. *Rome in the Age of Bernini, Volumes 1 and 2*. Atlantic Highlands, N.J.: Humanities Press, 1982.

Metropolitan Museum of Art. *The Age of Caravaggio*. Exhibition Catalog. New York: Metropolitan Museum of Art, 1985.

Mormando, Franco, ed. *Saints and Sinners: Caravaggio and the Baroque Image*. Boston: McMullen Museum of Art, Boston College, 1999.

Naphy, William, and Andrew Spicer. *The Black Death and the History of Plagues, 1345–1730*. Charleston, S.C.: Tempus Publishing, Ltd., 2000.

Orr, Lynn Federle. *Classical Elements in the Paintings of Caravaggio*. Ann Arbor, Mich.: University Microfilms International, 1982.

Rock, Michael. *Forbidden Friendships: Homosexuality and Male Culture in Renaissance Florence*. New York/Oxford, England: Oxford University Press, 1996.

Acknowledgments

M UCH OF THIS BOOK WAS WRITTEN while I was at the American Academy in Rome. I would like to thank everyone connected with the academy, especially Dana Prescott, Ingrid Rowland, Pina Pasquantonio, Lester Little, Leela Gandini, Chris Huemer, and Adele Chatfield-Taylor. I would also like to thank Ingrid and Dana for the walking tour of Rome's Caravaggio sites, and for Ingrid's suggestion that Helen Langdon's marvelous Caravaggio biography, *Caravaggio: A Life*, be referred to as the ultimate authority on much-debated questions concerning Caravaggio's life. This book could simply not have been written without Langdon's thoughtful and lucid work. Shilpa Prasad was immensely helpful and generous in agreeing to read the manuscript and offering incisive corrections and suggestions. Finally, I'd like to thank my editors, Terry Karten and James Atlas, my agent, Denise Shannon— and, as always, my family.

EMINENT LIVES

ISBN 978-0-06-114845-3

ISBN 978-0-06-176889-7

ISBN 978-0-06-176892-7

ISBN 978-0-06-176888-0

When the greatest writers of our time take on the greatest figures in history, people whose lives and achievements have shaped our view of the world, the resulting narratives—sharp, lively, and original—allow readers to see that world in a whole new way.

THE EMINENT LIVES SERIES

- Christopher Hitchens
 on Thomas Jefferson
- Edmund Morris on Beethoven
- Karen Armstrong
 on Muhammad
- Paul Johnson
 on George Washington
- Francine Prose on Caravaggio
- Joseph Epstein
 on Alexis de Tocqueville
- Robert Gottlieb
 on George Balanchine
- Michael Korda
 on Ulysses S. Grant
- Matt Ridley on Francis Crick
- Peter Kramer
 on Sigmund Freud
- Ross King on Machiavelli
- Bill Bryson on Shakespeare

Available wherever books are sold, or call 1-800-331-3761 to order.